# Digital Infrared Photography

Cyrill Harnischmacher

# Digital Infrared Photography

rockynook

Editor: Gerhard Rossbach · Translation: Reinhard Kargl · Copyeditor: Joan Dixon
Layout and Type: Cyrill Harnsichmacher · Cover Design: Helmut Kraus, www.exclam.de
Printer: Friesens Corporation, Altona, Canada • Printed in Canada

ISBN 978-1-933952-35-2

1st Edition
© 2008 by Rocky Nook Inc.
26 West Mission Street Ste 3
Santa Barbara, CA 93101-2432
www.rockynook.com

First published under the title Digitale Infrarotfotografie · © Cyrill Harnischmacher, Germany 2008

Library of Congress Cataloging-in-Publication Data

Harnischmacher, Cyrill.
[Digitale Infrarotfotographie. English]
Digital infrared photography / Cyrill Harnischmacher. -- 1st ed.
p. cm.
ISBN 978-1-933952-35-2 (alk. paper)
1.  Infrared photography--Handbooks, manuals, etc.
2.  Photography--Digital techniques--Handbooks, manuals, etc.  I. Title.
TR755.H3713 2008
778.3'4--dc22
                          2008025183

Distributed by O'Reilly Media
1005 Gravenstein Highway North
Sebastopol, CA 95472

Special thanks to Urte, Tabea, Jona, and everyone who has contributed to the creation of this book.

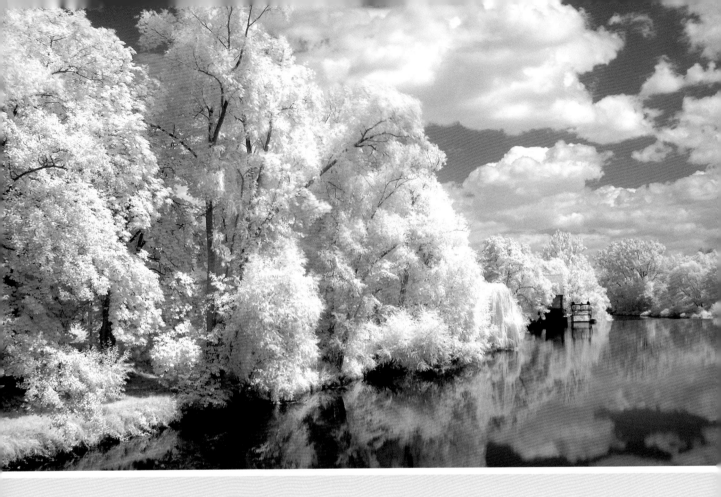

▲ *The River Neckar at Neckarhausen,*
*Nikon D70S, 24 mm, aperture 7.1, 2 sec.,*
*ISO 200, Heliopan RG780, Channel Swap.*

# Introduction

Infrared photography works in the domain of invisible light, revealing to us parts of the world that the human eye cannot perceive. Not only does it reveal an alternate perception of our world, but also offers us the possibility to set visual moods that are unattainable through photography in visible light. Combined with digital picture processing, infrared opens up an array of creative tools to the photographer. This can range from the simple conversion of images into black and white, to experimental color modifications. Having all these options also calls upon photographers to employ infrared techniques deliberately and purposefully, rather than just for visual effect. Though more time consuming than regular photography, the additional effort is sure to produce quite rewarding results.

Even though the advance of digital technology represents a simplification in comparison to analog photography, it would be wrong to assume that infrared photography is quick and easy. Features such as sophisticated focusing software, rapid auto-focus functions, or a high rate of exposures per second offer no big advantages in this arena. On the contrary—these technical gimmicks tend to distract from the needed time and tranquility in order to compose a perfect picture. Although, many of us would rather work only with manual or automatic shutter speed control and call it a day, making do without complex technology does not necessarily make photography more difficult. Instead, it can help to raise awareness of other criteria such as ideas and concepts, composition and moods—the basic elements of classic photography come to the forefront.

Working in infrared light necessitates the use of tripods, filters, and long exposures. This may seem cumbersome at first, but it tends to have the effect of preventing the rush and hectic disharmony that often characterize photographic work. Once a photographer has become accustomed to working in a calm and deliberate manner, each shot will be part of a ceremonial and ritualistic experience. Calm sets in. Thus, infrared photography is really a deceleration, and of course, this becomes visible in the pictures taken in this way. It might be rewarding to bring a part of this soothing calmness back into our "normal" photography as well.

Cyrill Harnischmacher

# Content

# Theory

# Some Basic Theory

The digital revolution in photography has greatly simplified infrared photography. Before the advent of digital electronics, cameras had to be loaded with highly sensitive infrared film while using special dark pouches. Then, photographers had to find a lab equipped to process infrared film, or they could opt to do the processing themselves. Either way, there was a long delay before the photographic results could be inspected. Today, a digital camera, a simple infrared filter, and some basic know-how suffice to reward even a beginner with quite satisfying results.

First, let's take a brief look at the basic principles of infrared. Like radio waves, x-rays, or radar waves, all light consists of electromagnetic radiation. However, the human eye can only see this radiation in the wavelengths between 380 nm and 780 nm (nm = nanometers). Outside of this range, shorter wavelengths are called "ultraviolet" (from Latin: ultra = beyond); and we call the longer wavelength "infrared" (from Latin: infra = below). In the year 1800, musician and astronomer Frederick William Herschel first detected infrared light by letting sunlight pass through a prism to break it into spectral colors. Herschel was able to measure temperature changes outside of the spectrum's visible red light, and he corrrectly attributed the rise in temperature to an invisible radiation.

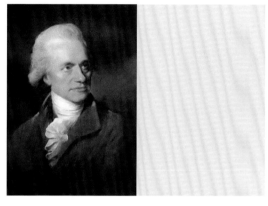

▲ *Frederick William Herschel (1738–1822) discovered not only the planet Uranus in 1781, but in 1800 he also proved the existence of invisible infrared radiation by measuring temperatures of light.*

Today, we have many technical uses for infrared light, for example in many areas of medicine, for the transmission of information through fiber optic cables or to connect computers, and in astronomy. A common application everyone is familiar with is remote controls, which use infrared light to control electronic equipment such as stereo systems. Photographers will also be familiar with the use of infrared technology in the data exchange between camera and flash units.

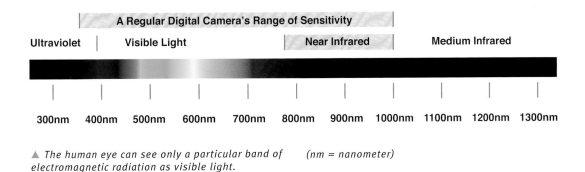

**A Regular Digital Camera's Range of Sensitivity**

| Ultraviolet | Visible Light | Near Infrared | Medium Infrared |

300nm   400nm   500nm   600nm   700nm   800nm   900nm   1000nm   1100nm   1200nm   1300nm

▲ *The human eye can see only a particular band of electromagnetic radiation as visible light.*

*(nm = nanometer)*

Infrared photography makes use of the spectral range right next to the visible red light, between 780 nm and 1000 nm, which is often called "near infrared". The first applications were for military purposes, for example to overcome the obscuring effects of camouflage paint on enemy tanks. Near infrared photography has since found many scientific applications. Ecologists, archeologists, astronomers, forensic investigators, and art historians all make use of the different reflective properties of materials in infrared light, wich allows for the identification of fakes and improves the legibility of damaged historical documents. Older versions of paintings, over-painted sections, or traces of previous renovations can be made visible. Comparisons of forest pictures may show changes in plant growth and point out environ-mental damage sustained over long periods of time. However, near infrared photography is not to be confused with thermal infrared imaging, which is a different technology called "thermography" and works with long infrared waves from 8 μm to 12 μm (μm = microns). It makes use of an effect whereby all solid surfaces radiate a certain amount of infrared light: the warmer the object—the brighter it shines in this spectrum. Thermography is often employed to improve the insulation of buildings: heat escaping from walls, windows, or roofs becomes brightly visible, and improving insulation of these areas can save a lot of money. Thermography can also be used to detect cracks and faults in industrial materials, depict the flow of energy, and optimize processes. However, thermography requires special sensors,

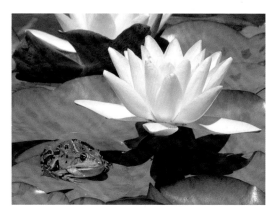

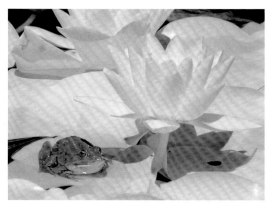

▲ *Perfectly camouflaged in visible light. Because its skin tones blend into the surroundings, the frog on the water lily leaf is hard to spot. Only the flower appears in contrast to the green leaves.*

▲ *In near infrared. Compared to the water lily's leaves and flower, the frog now reflects less infrared light, which makes it stand out.*

and lenses from the same glass used in conventional photography are opaque to this long-wave infrared radiation.

What makes near infrared especially interesting for photographers is the alternate reflection of light, compared to the visible spectrum. First described by and named after the American physicist Robert Williams Wood in 1919, the "Wood Effect" causes all green parts of a plant to appear bright white in near infrared light. The reason is that chlorophyll is highly transparent in infrared light, and all the water contained in a plant reflects infrared light brightly. For plants, this effect is extremely important, because too much absorption of infrared light could lead to overheating, water loss, and damage to a plant's tissues. Depending on the amount of cloud cover and angle of the sun, blue skies appear dark to black. White clouds, on the other hand, are accentuated. Cloud structures that are invisible to the naked eye may become visible. As a result, deep blue skies may look completely different in infrared.

▲ Yellowed varnish makes the restoration of old buildings difficult. An exact analysis often necessitates a thorough and expensive cleaning. An image in near infrared brings to light the results of earlier restorations, and also the painter's drafting lines—as seen here in the background landscape.

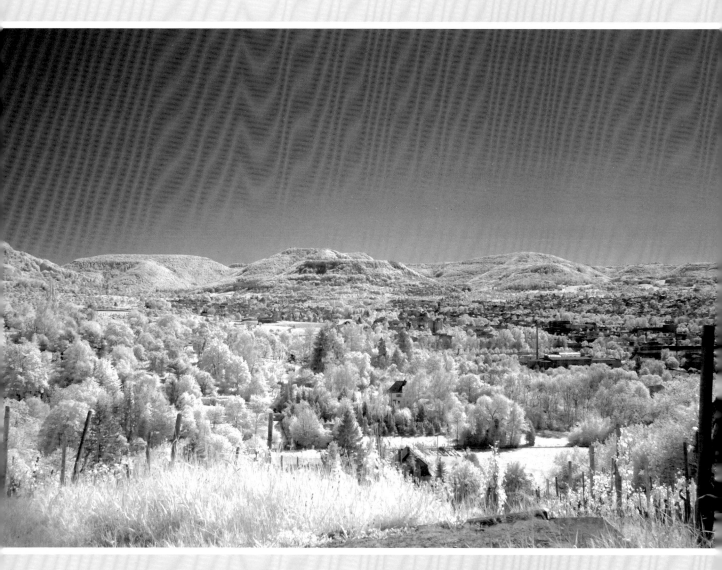

▲ At the edge of the Swabian Alb, a plateau and popular recreation area in the German state of Baden-Wuertemberg. Nikon D70S, 24 mm, aperture 6.3, 1.5 sec., ISO 200, Heliopan RG780.

Dust and moisture in the air absorb more of the shorter-wave visible light, but less of the longer-wave infrared light. As a result, the view in infrared extends to much greater depths.

The altered representation of skin tones in infrared makes portraits or nudes rather difficult. On the one hand, skin surface becomes somewhat idealized and imperfections disappear almost entirely: on the other hand, the skin takes on an unnatural, feature-less, and bland quality. However, if used in the right context, these effects can produce quite interesting moods.

Another hallmark of infrared pictures is the reduction of visible airborne dust and moisture. The longer waves of the infrared spectrum diffuse less than the shorter visible waves. As a consequence, distant objects will reproduce with more clarity and sharp-ness. This can be an important factor, especially in landscape and aerial photography. Although the foundation of infrared photography lies in black and white, it is possible to show colors by including visi-ble daylight.

▲ *The Wood Effect causes a green leaf in sunlight to appear bright white in near infrared.*

▲ *The legibility of firedamaged documents may be improved or restored on images in near infrared. On the left is a picture in visible light. The right shows an infrared shot made with a Heliopan RG780.*

# Equipment

# Cameras, Filters, and Accessories

The two most important questions for the novice infrared photographer are most likely, "What camera and accessories do I need?" and "Can I simply use my existing camera?"

In general, modern digital cameras are suitable for infrared photography. Their sensitivity extends outside the bounds of visible light, and ranges from about 370 nm in the ultraviolet range to about 1000 nm in the infrared range. However, camera models vary greatly. In analog infrared photography, light sensitivity is mostly a function of the film we use. But in digital infrared photography, light sensitivity is solely a matter of camera design. Camera manufacturers make use of filters to prevent the sensors from picking up too much ultraviolet and infrared light. These filters are usually placed on the chip itself. Because every camera model has different filters, each type of camera differs in its degree of infrared sensitivity, which results in differences in the required shutter speed.

**Infrared Test**

A simple test can determine your camera's suitability for infrared photography. Hold a regular remote control (for example, for your stereo system) and, while facing it toward your camera's lens, hold down any button. If your camera has a live liquid crystal

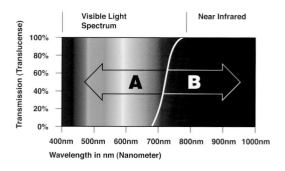

▲ *Infrared filters block a large portion of the visible light spectrum (A) and let only electromagnetic radiation of wavelengths close to near infrared pass (B).*

display (LCD) screen, look at it; or, if your camera does not have an LCD screen (for example, some digital SLR cameras), select a long exposure time and take a picture of your remote control (while continuing to press one of the buttons). If the remote control's light-emitting diode (LED) shows up as a bright dot of light (either on the camera display or on the resulting picture), then you are in luck.

**Compact and Bridge Cameras**

In order to convert a camera to infrared capability, a basic requirement is that there must be a way to attach an infrared filter to your camera. Many bridge

cameras have a threaded ring around the front lens, which will hold filters directly. Some compact cameras can accept filters through a special adapter tube, which allows the zoom lens to expand and withdraw freely within the tube. If none of these options work, you might try to attach filter foils to cameras without threading, but this is not very practical. The problem is that the connection must seal properly, and it must be stable enough to remain in place without becoming loose. In addition to the ability to hold a filter, your camera should have the option to be controlled manually, because its various automatic settings are not designed for infrared light and can be fooled too easily. Most likely, your pictures will come out over- or underexposed.

Digital compact and bridge cameras display the picture on an integrated screen. This usually works just the same even with an attached infrared filter. Compared to SLR cameras without a display, this is a major advantage for the purposes of selecting and framing the subject – and for judging the focus. However, when it comes to suitability for infrared photography, there are tremendous differences among the various camera models. Examples of popular "infrared" cameras are the early Canon Powershot models (series G1 to G3). Their internal

▲ *A regular remote control can be used to test whether your camera is capable of infrared photography.*

*Adapter tubes may make it possible to attach infrared filters even to compact cameras.*

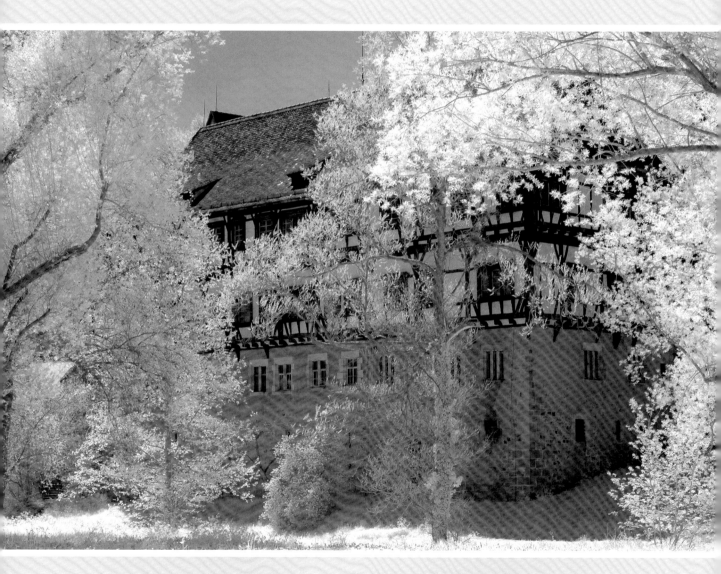

▲ *Monastery and Castle Bebenhausen near the German city of Tuebingen. Sparse spring foliage produces a light* *and airy mood. Nikon D70S, 50 mm, aperture 8, 2 sec., ISO 200, Heliopan RG780.*

infrared filter allows relatively high levels of infrared light to pass through. This means that these cameras work even with moderate exposure speeds. However, with these a tripod will be necessary.

### Digital Single Lens Reflex (DSLR) Cameras

As a result of the light path in digital SLR cameras, their viewfinder image will darken as soon as an infrared filter is attached, making it necessary to set up the shot before adding the infrared filter. As a result, infrared SLR photography is a bit tricky. For these cameras, a tripod is absolutely necessary; otherwise, the shot's framing could not be maintained while attaching the filter. But there are also advantages: SLRs offer superior image quality, and because of their larger sensors, longer exposures are not afflicted by as much "noise". The Nikon models D70 and D70S, in particular, have proven to be excellent choices for infrared photography due to an internal filter that allows a fair amount of infrared light to pass through. Practically speaking, this means exposure times of 1 to 2 seconds, at ISO 200, an aperture of 8, and the use of an RG780 filter.

Other cameras, such as the Canon 30D or the Fuji S3 Pro, may require exposure times of 30 seconds at the same parameters. It becomes clear that for all intents and purposes, infrared photography deals with long exposures. The only exceptions to long exposures would be with cameras that have been especially designed for infrared photography, or cameras that have been modified accordingly. All this is explained in the section on "Specialty Cameras". (See pages 24-34)

*A high-quality ball mount, a solid and stable tripod, and a lens hood are basic equipment for infrared photography.*

▲ *High-quality lenses with a fixed focal length are excellent choices for infrared photography. The infrared marking in this example (the tiny dot to the left of the central focus mark) allows for the easy correction of focal aberrations, which are typical of lenses without apochromatic qualities.*

## Suitable Lenses

In general, lenses of all focal lengths may be used for infrared photography. However, shorter focal lengths are more useful, because landscape photography is a major application of infrared techniques.

Zoom lenses may also be used. Even older lenses that are not compatible with the camera's automatic metering can be dusted off and put to work. (In infrared photography, aperture and shutter speed are almost always selected manually anyway.) Nor do autofocus functions or a high light throughput play an important role. Only the optical quality of the lens itself matters. In this way, an optically excellent manual lens, which may be too inconvenient for everyday use, may be revived for infrared photography. In many cases such older lenses even have an advantage, as many of them have infrared markings that can be used to correct the focal aberrations produced by achromatic lenses. Because of the longer wavelength of infrared light, a regular lens focused in visible light will focus infrared light behind the camera's sensor. Such "achromatic" lenses have not been "corrected" to counteract this effect in all wavelengths. This problem is avoided with apochromatically corrected lenses, in which special kinds of glass brings infrared wavelengths into focus as well. Such lenses produce sharp infrared images even when focusing in visible light.

The cost of filters should not be underestimated. One determining cost factor is the filter's diameter, which depends on the lens on which it will be used.

For comparison: an infrared filter for the Sigma 20 mm 1.8 EX DG (filter diameter: 82 mm) costs about twice as much as a filter for the AF Nikkor 20 mm 1:2.8 D (same focal length, but the filter diameter is only 62 mm).

### Infrared Filters

We want only near infrared light to reach the camera's sensor, so we need a filter to block out all or most of the visible light. Most filters are marked with a number telling us which wavelengths can pass through the filter. For instance, if a filter is marked RG665, we know that it will be translucent to wavelengths above 665 nm. Its translucence extends into the visible red part of the spectrum, which borders on infrared light. Therefore, this kind of filter makes a wonderful accessory for creative coloring experiments. Another example would be a filter marked RG780, which will only be translucent to wavelengths above 780 nm, and therefore will block just about all visible light. This type of filter is ideal for rendering black and white images.

Unfortunately, the various manufacturers don't follow a uniform convention when it comes to marking

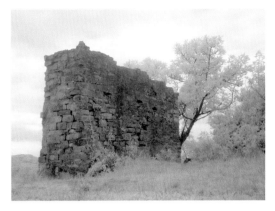

▲ *The photographic results using unexposed slide film as a filter are similar to those using an RG715, except for the reduced image sharpness.*

*You can make an improvised infrared filter out of unexposed, but developed slide film. This will allow you to make your first infrared shots without much of a financial investment.*

their products. Sometimes this leads to confusion among novices. For instance, another common classification is the Kodak Wratten system.

In the Kodak Wratten system, 89B is the equivalent of an RG695, and 88A corresponds to an RG715; 87 is the same as an RG780, and 87C is like an RG830. And that's not all! A 091 from the manufacturer B+W is the same as an RG630; a 092 is like an RG695, and a 093 is the equivalent of an RG830. In other words: it is best not to rely on the manufacturer's product code, but to look at the translucency instead.

There is also a way to construct a provisional infrared filter. All it takes is an unexposed piece of slide film that has been developed, which would make it completely black. Just cut it so it fits into an old filter housing or between two glass sheets or UV filters, making sure to avoid light leaks at the edges.

Although the image quality achieveable with this type of contraption does not approach the quality possible with a commercially available filter, it allows us to experiment and make test shots for little or no cost. Owners of a Canon EOS have yet another option. The German manufacturer Astronomik offers its "Clip Filter System", which has been specifically designed for this camera. (See page 30.)

**Useful Accessories**

A stable tripod is essential in order to hold the camera steady during the long exposure times of infrared photography. Ideally, this should be combined with a high-quality ball mount or tilt and pan mechanism. No expense should be spared on these items. Also useful are wired or wireless remote controls for the camera, which are beneficial in avoiding camera shake. However, they do not help with another problem: a long time exposure's lack of focus because the subject is in motion while the exposure is taking place. Infrared photography is predominately a playing field for wide-angle lenses, which have a short focal length. Therefore, a fitting lens hood is very helpful to prevent sunlight from hitting the lens from the side.

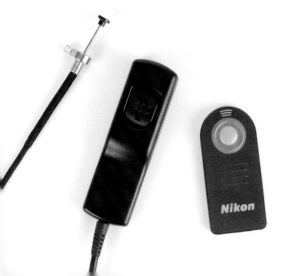

*The usual long exposure times mean a greater chance of focus loss caused by camera shake. To counteract this, wired or wireless remote controls are extremely helpful.*

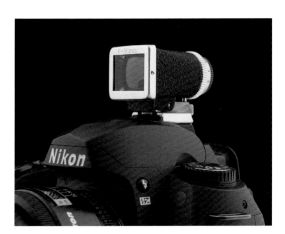

▲ *With SLR cameras, an attachable, external view-finder makes it possible to frame the picture even with an infrared filter attached to the main lens.*

▲ *Because most infrared photography will involve sunlight, a shade screen protecting the camera's display is also helpful.*

When using SLR cameras, having to attach and detach the filter several times to set up a shot can become annoying. With luck, you might find a used external viewfinder in a photo store: some models can even simulate various focal lengths by means of attachable masks. This allows an exact framing of the shot even while the infrared filter remains on the camera's front lens mounting ring. After at test shot, fine corrections can be made by checking the camera display.

In bright sunlight, the camera's display screen is difficult to see. This makes it impossible to verify if the image is in focus and whether it has the qualities we are looking for. Under these conditions, a pop-up screen shade can be of tremendous help. Another useful little item is a lint-free, soft microfiber cloth and cleaning fluid. Most opticians will stock these items for eyeglasses. Be careful! Never put cleaning fluid on filters made from slide film, because this could dissolve the film's outer layers. Instead, just use a dry, soft cloth.

◀ Infrared photography does not always have to include foliage to display the Wood Effect. The dark rendering of the blue sky, combined with cloud structures and an interestingly shaped object in the foreground, can yield very appealing infrared shots. *Nikon D70S, 24 mm, aperture 7.1, 2 sec., ISO 200, Heliopan RG715.*

▶ The lantern's underside is lit by reflections from the building's front lawn. Nikon D70S, 28 mm, aperture 8, 6 sec., ISO 200, Heliopan RG780.

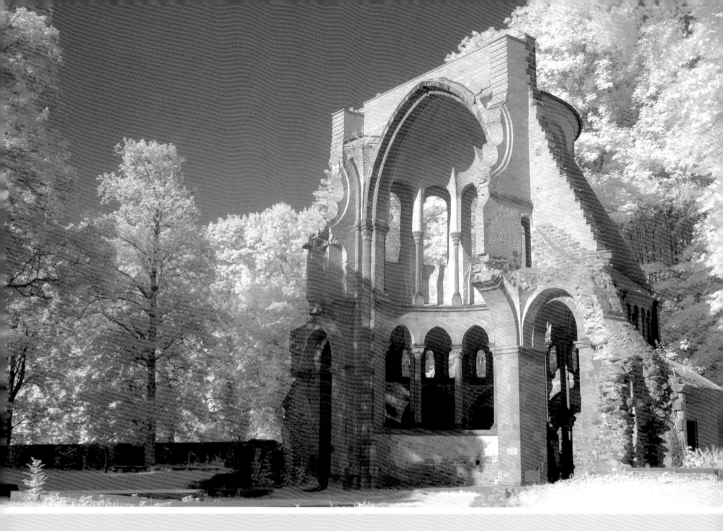

▲ *Ruins of Heisterbach Castle. Nikon D70S, 28 mm, aperture 8, 4 sec., ISO 200, Heliopan RG 850. Manual white balance.*

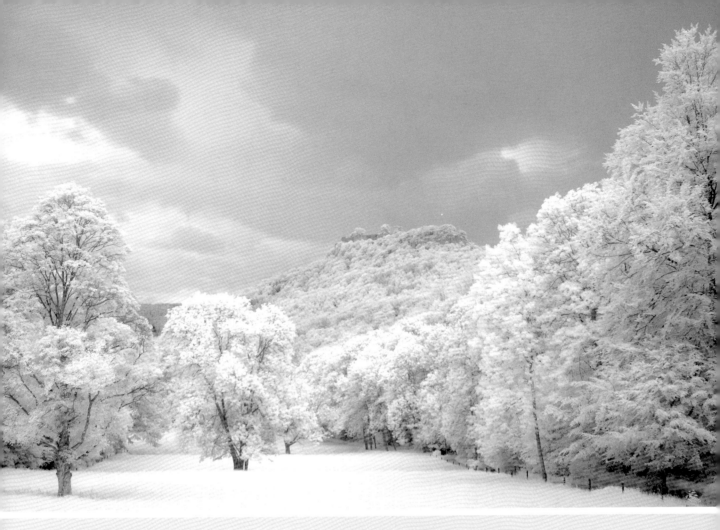

▲ Ancient ruins of Hohenurach. Infrared photography is possible even when the sky is overcast, but the shutter speed must be slowed down accordingly. In this picture, the cloud cover produces an image reminiscent of a winter wonderland. Nikon D70S, 28 mm, aperture 8, 8 sec., ISO 200, Heliopan RG850, manual white balance.

# Specialty Cameras

# Beyond Production Cameras

Cameras can be optimized to work with much greater sensitivity in infrared light. There are several ways to do this, but in all cases the camera's internal infrared blocker is removed. Depending on the intended use, the blocker is replaced with either a sheet of clear glass, or with an infrared filter designed for a specific wavelength. Cameras so modified offer a tremendous advantage over regular production cameras. The improved light sensitivity results in short shutter speeds, which often reduces the need for a tripod. Handheld head shots and pictures of moving objects become possible without the typical blurring caused by motion. Replacing the internal infrared blocker with clear glass frees up the sensor's full sensitivity. We can still selectively remove unwanted wavelengths from the image by attaching the appropriate filters to the main lens. This makes photography in UV light possible, yet, the camera's ability to function in visible light can be restored with the correct filter.

If an infrared filter is permanently attached to the camera, it can no longer be used for visible light photography. Unless we select a filter that is close to the visible red light, the camera is narrowly restricted to a particular wavelength. For example, with a permanent 850 nm filter, shots in 715 nm are no longer possible, since this wavelength can no longer reach the sensor. But if we permanently attach a 715 nm

▲ *A modified camera makes even snapshots possible. Infrared optimized Nikon Coolpix 5400, 28 mm, aperture 4.4, 1/500 sec., ISO 50.*

filter, we can still use an 850 nm filter on the main lens to further restrict the spectrum as needed. This makes it possible to produce color images as well as pure black and white shots.

By following directions found on the internet, camera modification can be a do-it-yourself project, but this introduces the danger of causing irreparable damage to the camera. In some cases even the work itself may even be dangerous. Beware! If opening the camera exposes the capacitor for the flash, an unsuspecting home mechanic could receive a

potentially lethal electric jolt. Recently, several camera companies have begun to offer professional conversion work, which also includes adjustments to the autofocus to ensure that the modifications do not result in blurry images. Of course, the original warranty becomes invalid in either case. It may seem prudent to convert a camera only after its warranty has expired anyway.

Special-purpose infrared production cameras are a different matter, however, as these are usually built for scientific and research purposes in extremely small numbers. One such example is the Canon 20D, which is built and optimized for astrophotography. Its internal infrared blocker allows heightened sensitivity in the h-alpha color band at 656 nm, which is barely in the visible red spectrum, making this camera perfect for astronomers. The SLR S3 Pro UVIR by Fuji has a much more transparent filter compared to the base model, and in combination with its 12 megapixel resolution, this camera delivers stunning details. Based on this camera, there is also its successor model S 5 Pro. The bridge camera Fuji IS-1 with a resolution of 9 megapixels is based on the Fuji FinePix S9500. This camera works between 400 nm and 900 nm.

All these camera models are great when it comes to combining infrared photography with conventional color photography. On the other hand, these specialty

▲ *Infrared action photography may be unusual, but it is indeed possible. Infrared modified Nikon Coolpix 5400, 36 mm, aperture 4.0, 1/1000 sec., ISO 50.*

cameras are made in small numbers. Their high cost matches the cost of professionally converted conventional cameras. Also on the downside: these specialty cameras are not widely available, often disappear from the market, or they may only be offered in certain countries.

▲ *Because of its "Night Shot" mode, the Sony DSC–F828 allows handheld infrared shots. Photo: Claudia Gitter.*

One model in particular, the bridge camera Sony DSC-F828, stands out because of its design. This camera's movable blocking filter can be snapped out of the way when it is not wanted for a particular shot. This camera also has a downside. Although the camera's "Night Shot" mode gives high infrared sensitivity, it also makes it impossible to select aperture and shutter speed. In bright sunlight, a gray filter is necessary.

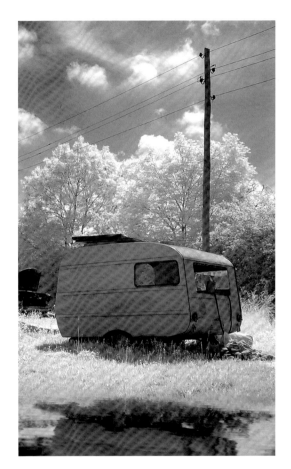

▲ *Sony DSC–F828, 35 mm, aperture 2.0, 1/60 sec., ISO 100, B+W 093 IR filter, 4 x gray filter. Photo: Claudia Gitter.*

# Optimized Infrared Cameras

**Compact Cameras (with internal infrared blocker)**

The internal blocking filter is permanently swapped for a fixed internal infrared filter. No additional filter is necessary on the main lens.

**Advantages:**

- High shutter speed
- No hot spot
- Adapter tube and threaded ring on main lens unnecessary

**Disadvantages:**

- Normal light pictures impossible

**Compact Cameras (with clear glass filter)**

The internal blocking filter is permanently swapped for a clear glass filter. An additional infrared filter is necessary on the main lens.

**Advantages:**

- High shutter speed
- The camera's ability to shoot in visible light is preserved if an infrared blocker is attached to the main lens
- A variety of infrared filters can be used

**Disadvantages:**

- Either an adapter tube or filter threading on the main lens is necessary
- Depending on the focal length, a hot spot can become visible in images

**SLR Cameras (with internal infrared blocker)**

The internal blocking filter is permanently swapped for a fixed internal infrared filter. No additional filter is necessary on the main lens.

**Advantages:**

- High shutter speed
- All lenses can be used without producing hot spots
- Focusing and setting up the shot can be done through the viewfinder

**Disadvantages:**

- Normal light pictures impossible

**SLR Cameras (with clear glass filter)**

The internal blocking filter is permanently swapped for a clear glass filter. An additional infrared filter is necessary on the main lens.

**Advantages:**

- High shutter speed
- The camera's ability to shoot in visible light is preserved if an infrared blocker is attached to the main lens
- A variety of infrared filters for different wave lengths can be used

**Disadvantages:**

- The viewfinder blackens when an infrared filter is attached
- Depending on the lens, hot spots may occur

◀ *The Wood Effect makes trees a highly interesting subject. Infrared optimized Nikon Coolpix 5400, 28 mm, aperture 2.8, 1/1250 sec, ISO 50.*

▶ *A castle's moat. The end of summer does not mean the end of infrared photography. Interesting subjects can be found even in winter. Infrared modified Nikon Coolpix 5400, 28 mm, aperture 4, 1/400 sec., ISO 50.*

# The Clip Filter System

Owners of Canon EOS cameras have another interesting option. Once the camera's internal IR blocking filter has been swapped for a clear glass filter, the Clip Filter System manufactured by Astronomik is an alternative to lens mounted filters. This system was originally devised for astrophotography; however, some of the filters offered by Astronomik can also be used in infrared photography. There are several advantages. First, only one filter is necessary for all EOS compatible EF lenses regardless of lens diameter. Secondly, during long exposures, the clip filter also protects the camera's sensor from dust. The Clip Filter System is presently compatible with EOS types 300D, 350D, 400D, 10D, 20D, and 30D. No further modifications are necessary; the filters snap right into the camera body, without the need for tools.

In addition to filters used in astronomy, two infrared filters are available at the time of this book's publication: 742 nm (ProPlanet 742) and 807 nm (ProPlanet 807). The disadvantage of this system is that the viewfinder darkens completely when the filter is inserted. This makes it difficult to arrange and set up the shot, which in most cases would have to be done before inserting the filter. The only way to circumvent this problem is by using an attachable, external view-finder as described in the chapter about equipment. Astronomik is developing an infrared (IR) blocking filter with the same properties as Canon's normal internal IR blocker. This will solve another problem by making it possible to quickly and cheaply restore the camera's visible light capabilities. Also in development are filters for other camera makes. You can find more information at www.astronomik.com.

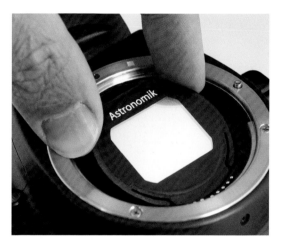

▲ *Clip filters are simply slipped into the camera housing and snapped in place. With this system, one single filter will work with all lenses regardless of the front lens diameter.*

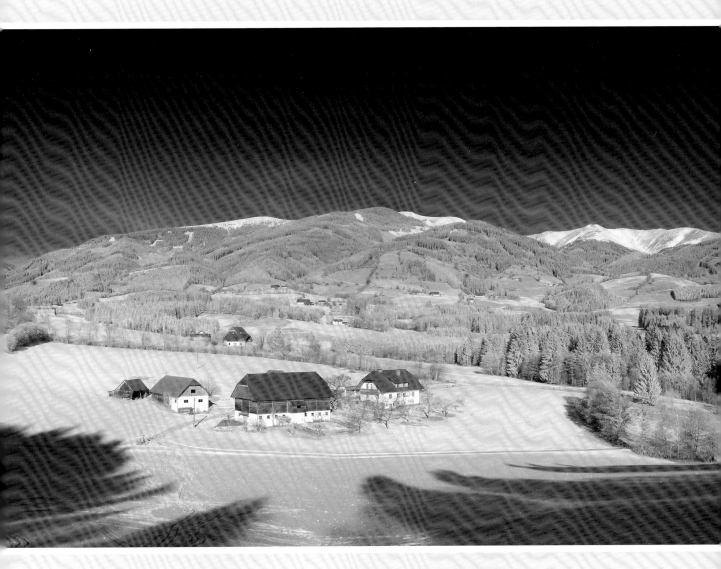

▲ Seckauer Tauern at Knittelfeld, Styria, Austria. Modified Canon EOS 350D without internal IR blocker, but with Astronomik

ProPlanet 742 Clip Filter, Canon EF 17-40/4 USM, aperture 8, ISO 200, 1/125 sec., Photo: Peter Wienerroither

# Sigma SD14-Infrared Photography Out of the Box

There is an SLR camera which allows both regular daylight photography as well as infrared photography without the need for expensive modifications: Sigma's SD14. This camera's internal IR blocker doubles as a dust shield and can easily be removed in case the sensor needs cleaning. On the SD14, this can be accomplished without any tools, but on the camera's predecessor, a tiny screw has to be loosened. The process is described in the camera's manual. When this filter is removed from the camera, the photographer can make use of the entire light spectrum from ultraviolet to near infrared. Once the filter is placed back in the camera, there is no infrared sensitivity at all.

One word of caution: if the camera is used without a filter, lens changes should be done in a dust-free environment to prevent airborne dust and debris from settling on the sensor. As with other SLR cameras, the viewfinder will darken once an infrared filter is attached. Again, this means that the picture has to be set up before the filter is applied. In most cases this means that a tripod will be necessary, even though the shutter speeds will be only slightly slower than what we might expect in daylight photography. Under sunny conditions, we could expect exposure times of 1/500 seconds or even less, using an aperture of 8. It is best to select aperture and

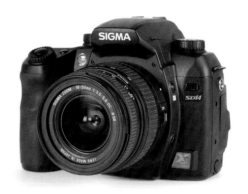

▲ *Sigma's digital SLR cameras SD14 and SD10 allow infrared photography with high shutter speeds but without expensive modifications.*

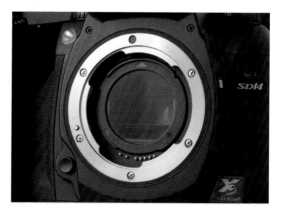

▲ *The internal IR blocking filter of the Sigma SD14 also functions as a dust shield and can simply be removed without tools.*

shutter speed manually, and to make the exposure rather low in order to avoid overexposure. Hand-held shots become possible with a little practice. This involves holding the infrared filter against the front lens after first setting up in visible light. Fortunately, the autofocus works well for this technique. Among the SD14's downsides is that it is impossible to adjust the white balance with an IR filter attached. This necessitates a use of the RAW-format and the successive conversion into black and white images, by using either the included converter software or any software that can perform this function. This method achieves much greater image quality and is therefore not necessarily a disadvantage. Using an appropriate filter (such as the RG715), the camera can also produce colored infrared pictures. However, labor-intensive conversion in a RAW converter or in other image editing software becomes necessary. The reason is that without the internal IR-blocker, the camera records a false color image. From this, interesting images can be produced by swapping out color channels and by performing other manipulations. Once the IR-blocker is inserted back into the camera, it is again fully capable of shooting regular daylight pictures.

▲ *Without internal IR-blocker, the Sigma SD14 records a false color image consisting of UV, IR and daylight combined.*

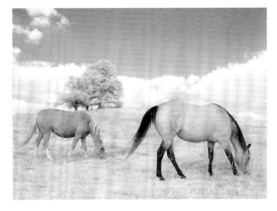

▲ *Because its fast shutter speed counteracts blurring, the SD14 can also be used for subjects in motion.*

# A Brief Excursion into Astrophotography

Anyone who goes through the trouble of replacing a camera's internal infrared blocker with a clear glass filter has the perfect opportunity to take a stab at astrophotography. The modification results in much shorter exposure times, or in other words, a much greater number of stars can be photographed at a given exposure time when compared to unmodified cameras. The reason is that after the removal of the IR blocker, the camera sensor's entire sensitivity range from UV to IR light can be utilized. The images will have a pronounced reddish tint, but this is easy to fix with either a RAW converter or in any suitable image processing software. Simple overview shots of the starry sky can already be made with a wide-angle lens, as long as the camera is mounted on a stable tripod. Of course, the exposure time is limited because of the Earth's rotation, which makes it appear as though the stars were moving (i.e., trailing) through the image. At long focal lengths and with long shutter speeds, celestial objects no longer appear as dots, but rather as lines of light. As a rule of thumb, a 20 mm lens will allow exposures of 15 to 20 seconds without this trailing effect. If a 50 mm lens is used, the maximum possible exposure time is reduced to about four seconds. For any longer exposures, it is therefore necessary to move the camera in conjunction with the Earth's rotation, so that it remains stable in relation to the sky. The cheapest and most simple mechanism for this purpose can be found under the keywords "barndoor mount" on the Internet. This type of mount can be a do-it-yourself project, and it should be good enough for first experiments with exposure times of two or three minutes. Anything beyond this would require tracking with a precision-controlled parallactic mount and a telescope. Astrophotography works best with fixed lenses (as opposed to zoom lenses), a high ISO setting, and in the RAW file format whenever possible. For more on astrophotography see Rocky Nook's book, *Digital Astrophotography: A Guide to Capturing the Cosmos* by Stefan Seip.

▲ *A modified SLR camera and a short focal length will also deliver impressive images of the night sky.*

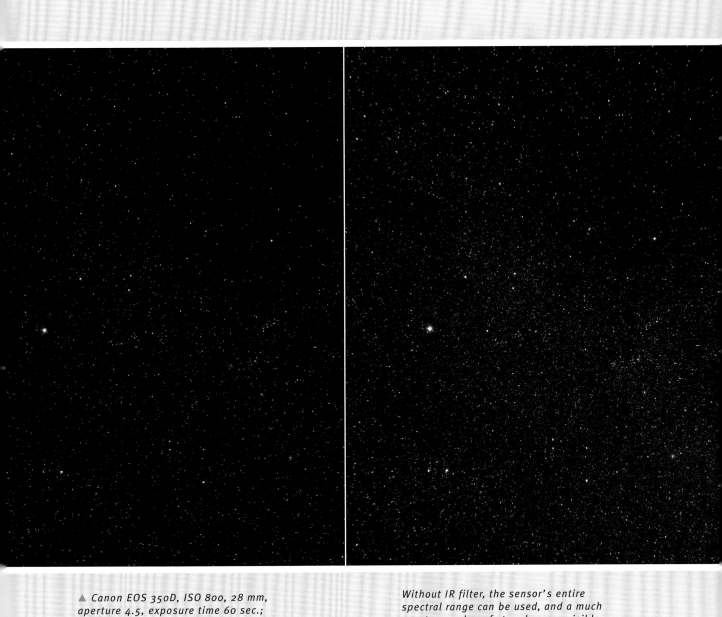

▲ Canon EOS 350D, ISO 800, 28 mm, aperture 4.5, exposure time 60 sec.; left picture with, right picture without internal IR blocking filter.

Without IR filter, the sensor's entire spectral range can be used, and a much greater number of stars become visible. Photos: Peter Wienerroither.

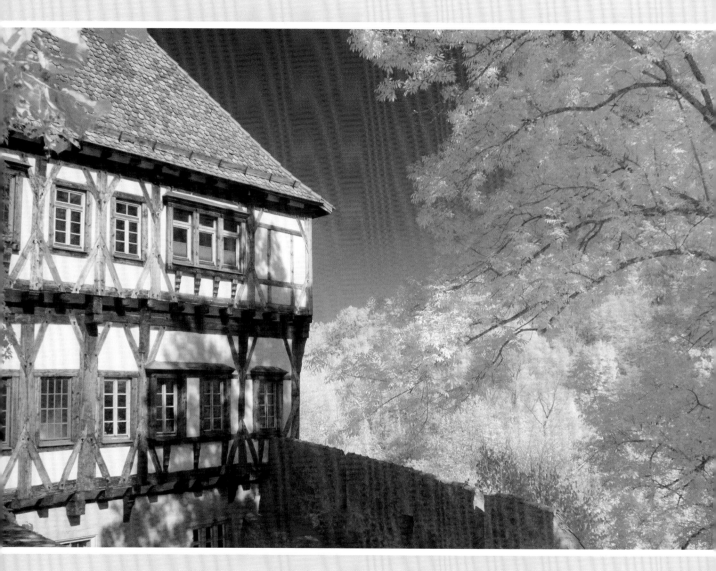

▲ Monastery and castle Bebenhausen
near Tuebingen. Sigma SD14 without
internal IR blocker, 18 mm, aperture 6.3,

1/500 sec., ISO 100, Heliopan RG780.

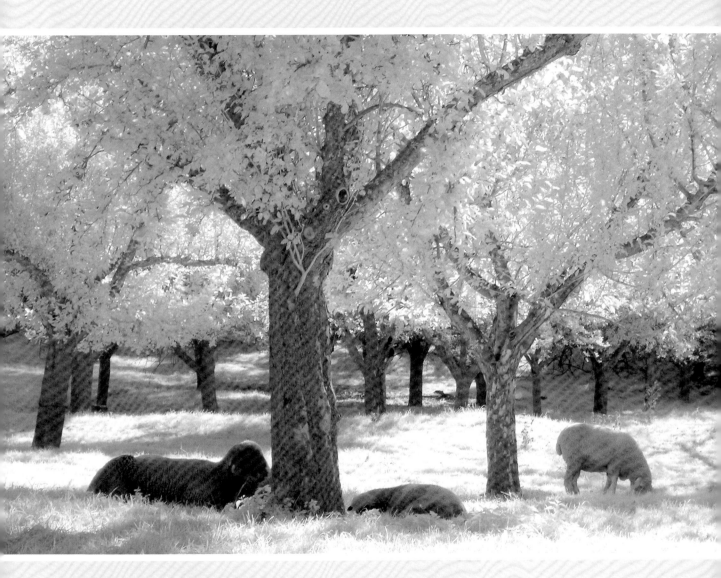

▲ *Sheep. Infrared optimized Nikon Coolpix 5400, 110 mm, aperture 6.3, 1/250 sec., ISO 50.*

# Practical Aspects

# White Balance, Exposure, and Settings

Let's jump right into the technical aspects, especially the control settings of the camera and on the lenses. Infrared photography is not a quick affair. There will almost always be a need for special preparations before the first shot is taken. We should not dismiss this as a disadvantage, but rather view it as an opportunity to immerse ourselves in picture composition.

## RAW, JPG, or TIF

Especially in infrared photography, the RAW format has a lot of advantages over other data formats such as JPG. RAW files are minimally processed and are sometimes referred to as the digital equivalent of a film negative. They are the best platform for further processing or conversion into other file formats. The superior image quality resulting from RAW files compensates for their disadvantages, such as the large data volume and a more time-consuming work flow. If the camera does not offer a RAW setting, the next best format would be TIF. JPG files have undergone compression and have the smallest file size, but the compression process results in a slight loss of image quality. Regardless of what file format is selected, the need for good exposure control is paramount. It is better to expose on the low side, because this leaves more processing options for later.

## ISO Setting

For ideal image quality, the highest resolution should be set in combination with the lowest ISO setting. Of course this makes the shutter speed longer and can cause more image noise, but this is still preferable to the loss of image quality at a high ISO setting. Because of their smaller sensor size, compact digital cameras are especially afflicted by this dilemma. Some camera models already reach their limits at 400 ISO. As a consequence, attempting to compensate for long exposure times by raising the ISO setting really offers no solution.

## White Balance

The automatic white balance will, depending on the kind of filter, cause a more or less pronounced reddish tint. Sometimes the red channel will be completely maxed out, which is sometimes difficult to correct through image processing. Performing a manual white balance before shooting is well worth the effort. In regular color photography this can be best achieved by pointing the camera at a neutral gray card or white paper. This exercise will produce natural colors and a good gray balance. In infrared photography, a sunlit lawn or green foliage replaces the gray card, because the result should be pictures in which green plants will be rendered white or neutral.

Of course, the white balance must be done with the infrared filter in place. One potential complication is that not every camera will accept such a white balance on the first attempt. It might be necessary to choose a manual setting and experiment with somewhat slower shutter speeds. Depending on the camera model, these settings may be saved, or it may be necessary to save a reference picture on which the given settings are noted. When working with several filters, it is a good idea to save a refer–ence picture for each filter, and then lock the files to ensure against accidental deletion. This makes it possible to refer back to these test shots.

Some cameras do not allow an individual white balance. In these cases it is best to select a white balance setting as close as possible to the red band. This counteracts an overexposure of the red wavelengths. If the camera allows files to be saved in the RAW format, it is also possible to perform the white balance during the RAW conversion at a later point.

### Aperture and Shutter Speed

Unless a camera has been modified for infrared photography, it is best to select the exposure settings in manual mode. Some experiments may be necessary to find the right shutter speed. Although the camera's internal light meter will detect infrared

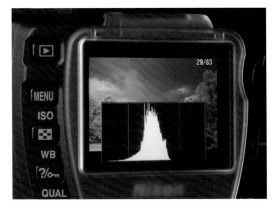

▲ *The camera's histogram display should be used for improved control. Most light conditions are almost impossible to evaluate from the camera's viewfinder image alone.*

light, the automatically calculated values are prone to error. This is a problem especially with cameras requiring double-digit seconds of exposure time. Sometimes, the best solution is to make a series of shots with varying shutter speeds. This way, an ideally exposed shot can be selected later. Even when the RAW format is used, the best raw material for a later conversion is an ideally exposed image. As a rule a tripod should be used, especially when several shots are taken and meant to be composited into one image later. With modified cameras the automatic setting is a good choice. Again, care should be

taken to avoid overexposure. Even underexposure is preferable. Perhaps an underexposure of 1/3 or 2/3 f-stops less could be considered a benchmark. Preset exposure programs will usually fail to produce good results.

**Focusing**

Users of digital SLRs will have to make do without autofocus. It will be necessary to focus without the infrared filter and then correct for focus aberrations manually. If the lens is not apochromatically corrected but has infrared markings, the necessary focus corrections are easily achieved by manually adjusting to the corresponding markings. On lenses lacking these markings, it is possible to add them. A narrow strip of adhesive paper imprinted with millimeter markings should do the trick. After attaching it to the lens, we can do a series of test shots adjusting the lens by one-millimeter increments each time. After determining the best focus setting on the LCD screen, markings can be made on the lens. This procedure is not needed with digital compact cameras. In most cases, their autofocus system will also work with the infrared filter attached. Small focus aberrations matter less with these cameras anyway since their smaller sensors have a much smaller depth of field to begin with. Whenever a camera is modi-fied

▲ *If there are no IR markings on a lens, a strip of millimeter ruled adhesive tape could be affixed and marked after taking a few test shots.*

for use with infrared light and the camera is outfitted with a fixed filter, the autofocus must be calibrated. This is another reason why the conversion is best left to professionals.

### Shutter Release

Even when the camera is mounted on a tripod, it can easily be disturbed by vibrations. This is why remote shutter releases are immensely helpful. The best solution would be a wireless infrared remote control. Some cameras do not allow remote shutter control. If this is the case, the only option is the camera's timed-release setting. Motion blur is often a result of long exposure times, for instance when the wind moves tree branches. This problem can only be avoided by patiently waiting for a calm moment.

### Hotspots

Hotspots are a problem we can run into with all types of cameras and are usually seen as circular, brighter spots in the center of the image. The size will change with the aperture settings. The culprit lies in reflections between the camera's sensor and the glass surfaces of lenses and filters. Owners of digital SLR cameras have the option of trying a different lens. But, if the hot spot appears in a digital compact or bridge camera, there really is no other solution but to attempt a removal with image-processing software. Only modified infrared cameras with internal IR filters do not suffer from this effect and can use all kinds of lenses.

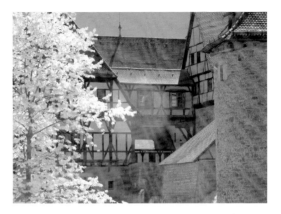

▲ *Unfortunately, a hot spot is clearly visible in the center of the image. Fuji S3Pro, Nikkor 1.8, 50 mm, Heliopan RG715.*

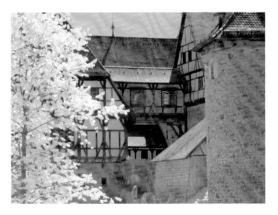

▲ *This shot, made with the same lens and the same filter, but with a different camera, has no hot spot. Nikon D70S, Nikkor 1.8, 50 mm, Heliopan RG 715.*

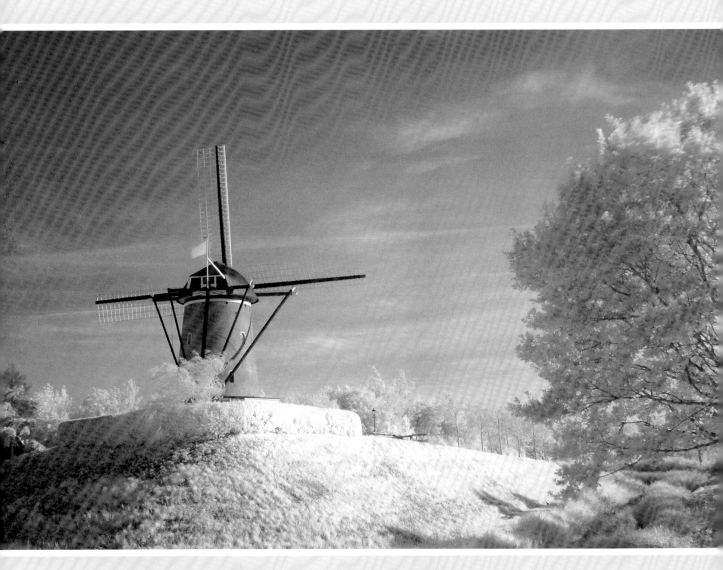

▲ Windmill. Nikon D70S, 24 mm, aperture 8, 4 sec., ISO 200, Heliopan RG850.

This filter, combined with a manual white balance, will lead to pure black and white images.

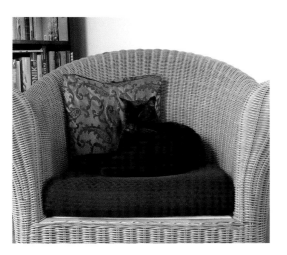

▲ *Materials that have matching colors in visible light may look completely different in infrared.*

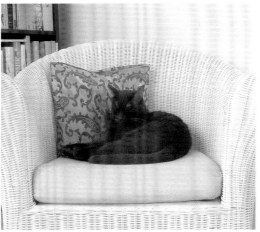

▲ *Black cats are always black—even in near infrared. But the chair and the black pillowcase appear white in infrared.*

## Color Rendering

Apart from the Wood Effect on green plants and the bright, waxy appearance of human skin, there are many other materials which will look quite different in infrared light. Synthetic fibers in particular, but also some cotton fabrics, are strong reflectors of infrared light and will therefore appear almost white regardless of their color in visible light. In general, colors lose not only their properties but also the gray value our sense of sight associates with each color. This makes it somewhat difficult to predict what an infrared shot will look like. For example, the attire of people at a wedding may lead to rather surprising results. It is therefore quite possible that the groom's suit turns from black to white when photographed in infrared light. The amount of reflected infrared light depends not only on the fabric material, but also on how it was dyed. Such unpredictable surprises can only be avoided by taking test shots.

# Infrared Filter Comparison

**RG 665**

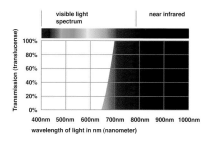

The proportion of daylight is relatively high. The Wood Effect is visible, but not very pronounced with this type of filter. This filter is best for creative color experiments. Handheld shots are still possible with high ISO settings, a large aperture, and bright light. The viewfinder of an SLR camera will show a red tint.

**RG 715**

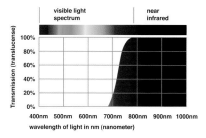

The Wood Effect is quite visible. The RG 715 is suitable for both "color" and black and white infrared shots and is therefore ideal for novices. A tripod is necessary, because the shutter speeds are too long for handheld shots.

**RG 780**

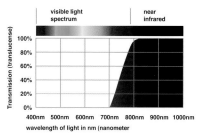

This filter shuts out most daylight. Whatever remains after performing a white balance will produce a brownish tint, which can be an attractive basis for a faint tone. A tripod is necessary.

**RG 850**

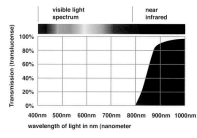

This is a full infrared filter. After a manual white balance, this filter will produce only black and white pictures. Even in bright sunlight, the exposure times are quite long. Accordingly, there is a high possibility of motion blurring, which could also be used creatively.

## Automatic White Balance

Left: Unprocessed image
Right: Automatically adjusted in RGB mode
Camera: Nikon D70S, Filter: Heliopan

## Manual White Balance

Left: Unprocessed image
Right: Brightness automatically adjusted in
LAB mode

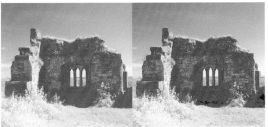

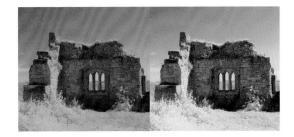

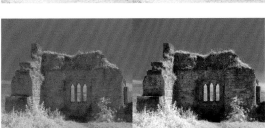

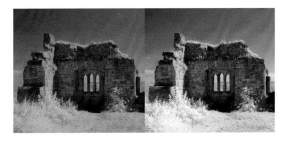

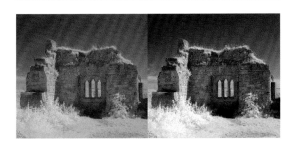

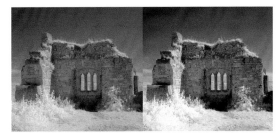

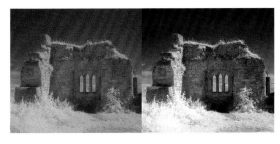

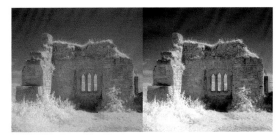

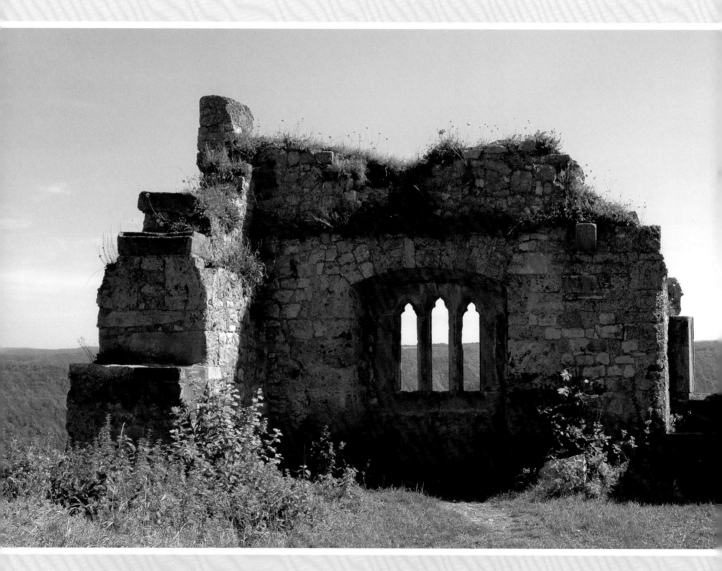

▲ *Regular daylight shot. Nikon D70S,*
*24 mm, aperture 6.3, 1/500 sec.,*
*ISO 200, white balance for sunlight.*

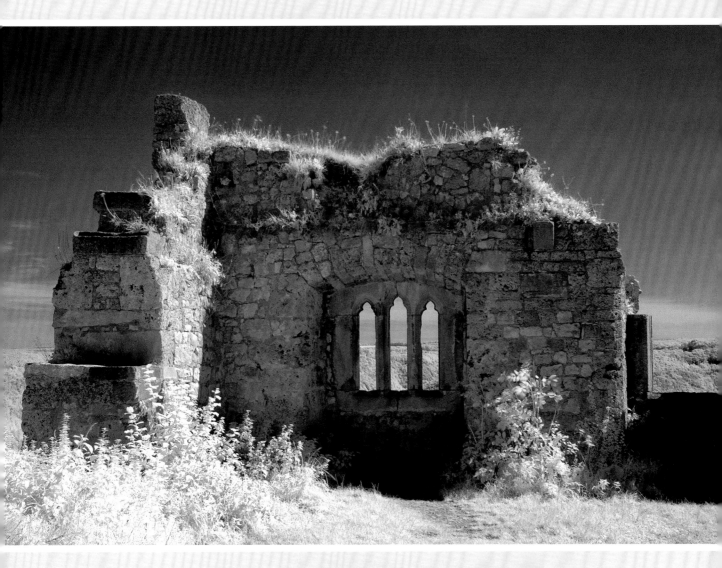

▲ Infrared shot. Nikon D70S, 24 mm, aperture 6.3, 2 sec., ISO 200, Heliopan RG780, manual white balance for green grass in sunlight. Conversion in LAB mode, manual correction of brightness, channel swap of red against blue in RGB.

◄ *The lush tree turns into an abstract sculpture concentrating all lines at th center. Infrared modified Nikon Coolp 5400, 28 mm, aperture 3.2, 1/200 sec. ISO 50.*

▶ *Shot against the sun, the foliage lights up while the trunk turns into an almost black silhouette. Infrared modified Nikon Coolpix 5400, 28 mm, aperture 2.8, 1/1000 sec., ISO 50.*

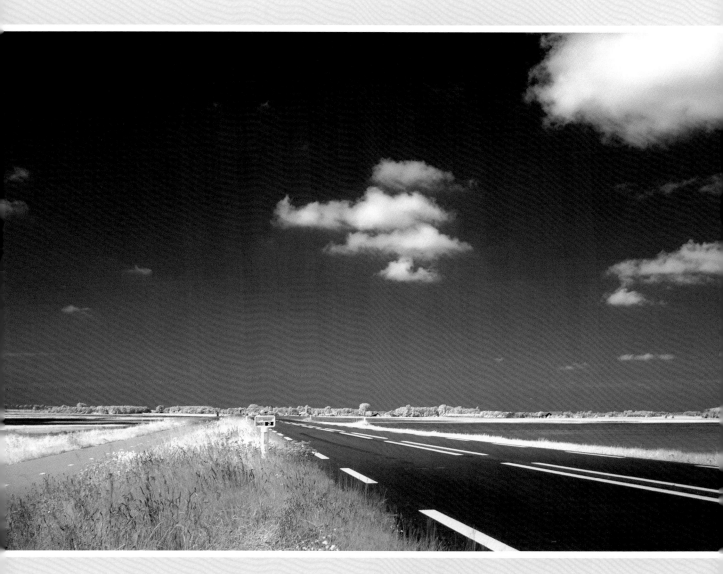

▲ Country road. The RG715 filter lets more daylight pass through, and is therefore ideally suited for "color" infrared photography. Nikon D70S, 24 mm, aperture 4.5, ? sec., ISO 200, Heliopan RG715.

# Composing and Setting Up Shots

To a large degree, infrared photography equates to landscape photography. This is where we find some of the most amazing things to see in infrared light. While the principles of conventional photography fully apply, we may of course, from time to time, forget about the rules and go wild with creative freedom. But the qualities of classic photography—composition, abstraction, and focusing on the essential—have the same importance in infrared light. However, there are a few special considerations: For one, we must consider the Wood Effect and pay close attention to contrasts that are likely to result from it. As an example, let's think about colorful flowers on a green, grassy meadow, which would look great as a color photograph. Using appropriate filters, this could also make an interesting black and white picture. But in infrared, the same meadow will yield only a bland area with little structure, because the colorful flowers and the grass reflect infrared light in quite similar ways. But, what if we choose a different perspective and shoot the flowers from below and against the clear sky? In infrared light the flowers will contrast well against a dark background. This example demonstrates the importance of the camera position. The best course of action is to contemplate several perspectives before taking a shot.

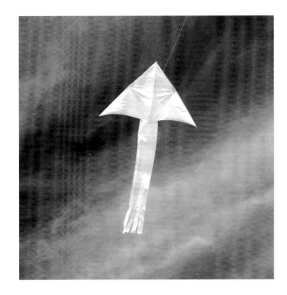

▲ *In this shot, the rainbow colors of the kite disappear and the kite is reduced to a graphic symbol. This kind of shot is only possible with modified cameras capable of high shutter speeds. With longer exposures, even the smallest movements of the kite would cause motion blur.*

One reason is that we just might find a better angle, but another benefit is that this kind of thinking ahead makes us more aware of why we chose a particular perspective in the first place.

▲ *The motion blur caused by long exposure times in windy conditions can produce patterns similar to brush-strokes in modern paintings.*

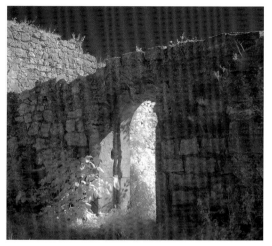

▲ *Even though this picture was taken in bright sunshine, the moonlight effect makes it appear to be a night shot.*

Another aspect of infrared photography is the tendency toward motion blurring, which is a result of the longer exposure times in infrared. Then again, this problem can be turned into a creative tool. A blurred swish can depict the movement of objects in a still picture by pointing out the contrast between moving and stable elements. In this way, the flow of water in a creek or trees moving in the wind in front of a building can suggest motion while at the same time accentuating the static part of the picture.

Since modified cameras will use fast shutter speeds even in infrared light, a gray filter on the front lens would have to be used when playing with these motion shots.

### The Moonlight Effect

Shooting the clear sky with the sun behind our backs will produce an almost black sky. With low exposure, this can create the impression of a night shot, and something we call the "moonlight effect". This effect

can be amplified by choosing the appropriate subjects. Because too much sunlit foliage does not work well with these kinds of pictures, the winter months can provide the perfect occasion for this type of photography, contrary to the myth that winter is not "infrared season". It is a good idea to experiment with several varying shutter speeds.

**The Soft Focus Effect**

The Kodak HIE 2481 is a popular film in analog infrared (IR) photography. It lacks a protective layer and delivers wonderfully smooth light overwash. With digital capture, we can approximate the effect of this film (at least partially) either while taking the shot, or through later processing. The simplest method at the time of shooting is the use of a suitable soft filter attached to the front lens.

Another interesting possibility to achieve a softening effect is the double exposure. This technique exposes the image twice: the first time in normal focus, to be followed by another shot with the lens set to be more or less out of focus. Not all cameras allow double exposures. But as long as the focus can be set manually, we have another option. First, we place the camera on a stable tripod and focus normally. After setting a small aperture to correspond with several seconds of exposure time, it would be a

good idea to take several test shots to make sure the settings are correct. After making sure we are good to go, we can release the shutter. Now here comes the trick: at the midpoint during the exposure, we "defocus" the lens by carefully turning the manual focus ring. Of course, this will cause some camera shake, but this is quite irrelevant because the picture resulting from this technique will be blurred anyway. The softening effect can be adjusted by defocusing earlier or later during the shot, which leaves the

▲ *A deliberate defocusing during the exposure draws a shining aura around the bright parts of the picture.*

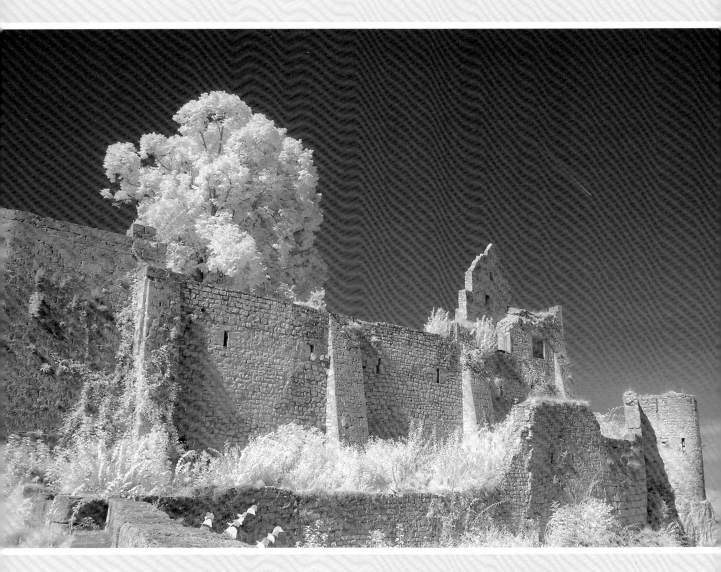

▲ The picture's overall harmonious, tripartite composition demonstrates the rule of thirds: the important elements are placed at the intersections of three vertical and three horizontal divisions. Infrared modified Nikon Coolpix 5400, 28 mm, aperture 4, 1/500 sec., ISO 50.

▲ *Some digital cameras can show a guide grid in the viewfinder or on the LCD display, which is helpful for finding the right composition.*

picture at varying degrees of base focus. In addition, the level of defocusing also plays a role. By noting all the settings together with the shot number we can reproduce the same effect on future occasions.

Whatever we do, special effects should never cause us to forget about classic photographic techniques. We should think about unusual perspectives and make them an integral element of our composition. The viewer can be guided into the picture by making use of existing lines, which can direct the viewer's eyes to the most important details. We should also think about how to integrate the foreground into our compositions. Let's not shoot only from eye level.

▲ *This picture shows not only tension between opposing forces, it also tells a story.*

Instead, we should look for camera positions and angles that not only show the subject in the best way, but also eliminate unwanted details. We should not only incorporate contrasts between bright and dark, but also between emotional tensions and opposing shapes. We can try both the vertical and

▲ *Shot through a short telephoto lens, from an elevated location across the street, this shot includes all the important elements, but looks rather bland.*

horizontal formats and experiment with various focal lengths to find the combination that gives our subject the best depth and appearance.

Try as we may, there will always be an element of uncertainty and surprise. After all, with infrared we are photographing something "invisible". Of course this is exactly what makes infrared photography so fascinating and exciting.

▲ *This shot, looking up from the tower's base, was taken with a wide-angle lens. The vertical format works much better; the shorter focal length and the different perspective lend a much more dynamic quality to this image.*

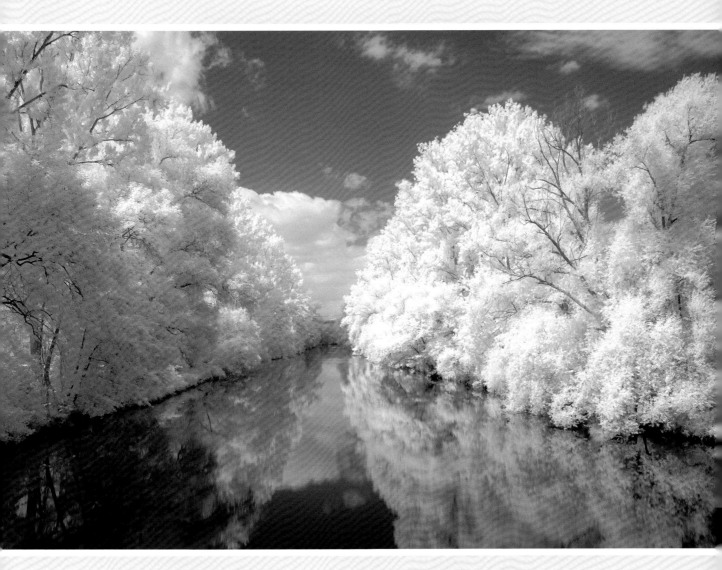

▲ The Neckar River in Germany. Even in infrared light, reflections make an interesting and rewarding picture. In this case, the viewer's eye is drawn into the shot by a nearly symmetrical arrangement and the central perspective. Nikon D70S, 24 mm, aperture 8, 3 sec., ISO 200, Heliopan RG780.

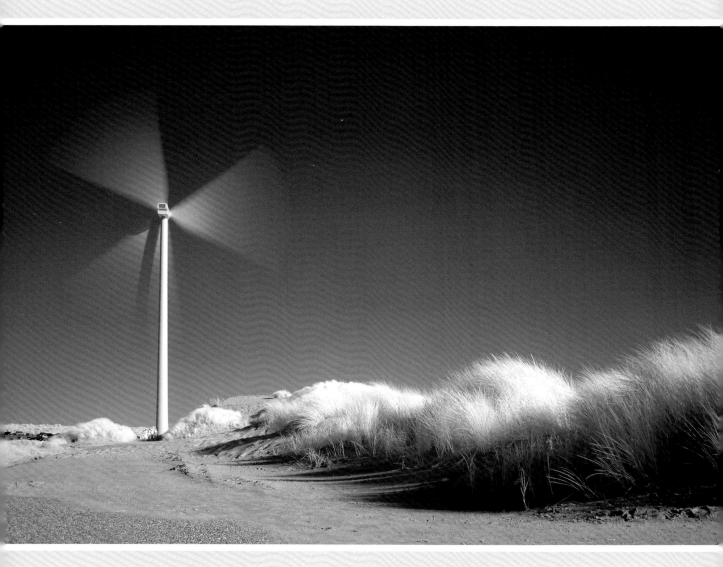

▲ Dunes and wind turbine. Color can also be a style element in infrared photography, but it is best used sparingly. Nikon D70S, 24 mm, aperture 2.8, 1/2 sec., ISO 200, Heliopan RG780.

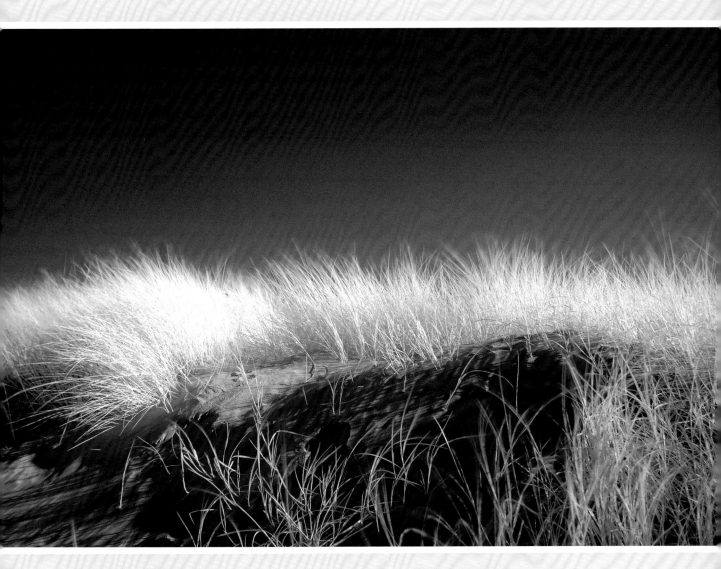

▲ *Dune grasses at the North Sea. In later processing, swaps of the red and blue color channels* produce a partially blue tint. Nikon D70S, 28 mm, aperture 5, 2 sec., ISO 200, Heliopan RG780.

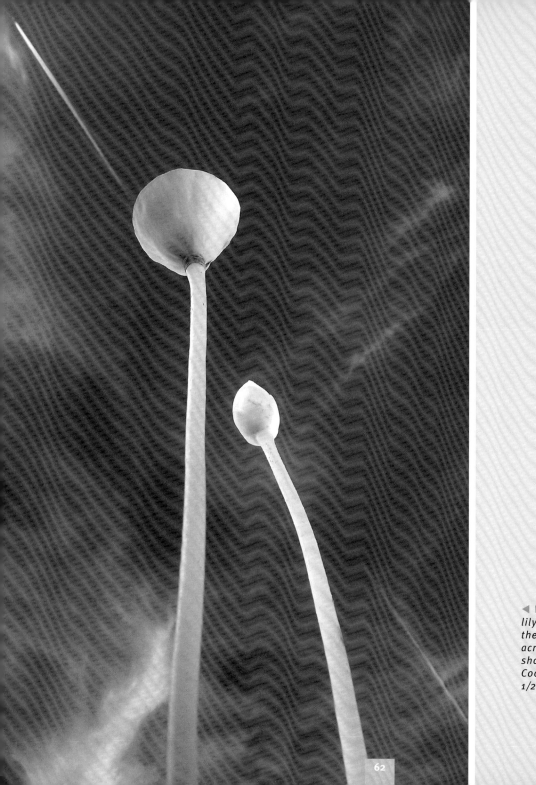

◀ *Water lilies. Surreal-looking water lily stalks, an unusual perspective, and the luck of having an airplane streak across the sky all contribute to this shot's appeal. Infrared modified Nikon Coolpix 5400, 28 mm, aperture 3.2, 1/200 sec., ISO 50.*

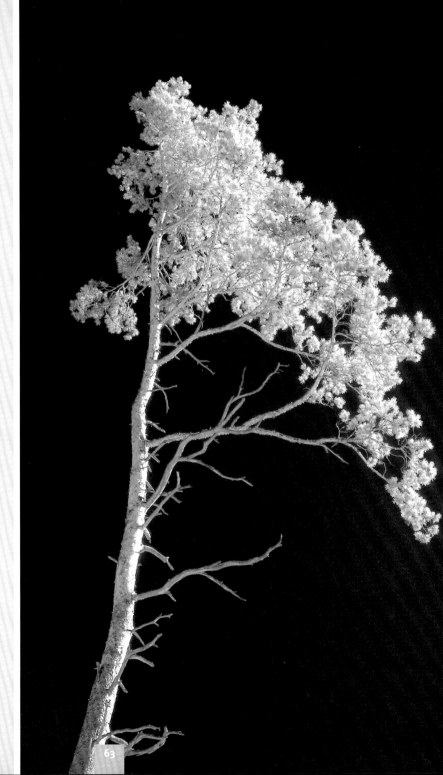

▶ *Tree in Schoenbuch. The position of the sun directly behind the camera turns the clear sky into an even black. Infrared modified Nikon Coolpix 5400, 80 mm, aperture 6.3, 1/90 sec., ISO 50.*

# Tabletop and Still Life

Because incandescent and halogen lamps emit part of their light in the form of heat (and therefore, infrared), these light sources are well suited for IR photography. Even a regular table lamp is enough to create interesting shots, and when shooting indoors, the distribution of light and shadow can easily be controlled. Since infrared photography usually results in black and white images, we do not have to worry much about unwanted color casts.

Photoflashes are another matter. They can only be used with modified cameras, but these allow the use of all kinds of flashes, from the camera's built-in unit to professional systems. One thing to consider is that flash pictures will usually turn out low in contrast, which is why soft light should be avoided. Black backgrounds may present a challenge. For background material, the commonly used black velvet—ideally suited to absorb visible light—is much brighter in infrared. I have had nice results with sheet metal painted

*Incandescent and halogen light can also be used in infrared photography.*

▲ *Bouquet of flowers. Infrared modified Nikon Coolpix 5400, 110 mm, aperture 7.2, 1/250 sec., ISO 50, two flash units with soft boxes.*

black, some kinds of black cardboard, and matte black acrylic. Only experiments can tell which materials will or will not work.

# Infrared Lightbrush

A regular flashlight with a focusing reflector makes an excellent lightbrush. This is a great way to make creative use of the long exposure times necessary with unmodified digital cameras. First, we need to mount the camera on a tripod and compose the picture. To avoid light scatter, it is necessary to darken the room, leaving only faint light so we can safely navigate the room. Then we open the shutter remotely and begin to shine the flashlight at all areas we plan to make visible in the picture. It is best not to direct the light on one spot for any length of time; continuous, slightly circular motions will result in smooth lighting and transitions. The first experiments will most likely fail to impress, but after a while we can develop a feel for the amount of light necessary and the right spots to illuminate to produce just the right result. It is possible to adjust the exposure time by

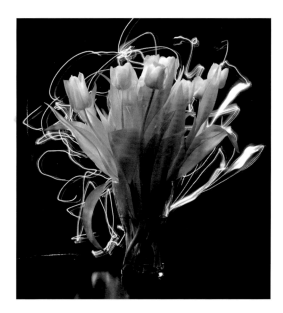

▲ *Tulips. Nikon D70S, 24 mm, aperture 4, 30 sec., ISO 50, RG 715, flash-light used as lightbrush.*

modifying the aperture and ISO settings. It's common to underestimate the remaining exposure time while working on the shot, which is why we should begin with a rather long exposure. This gives us more room to play. Counting the seconds also helps.

*A simple flashlight with a focusing head can be used as a lightbrush.*

# Macro Photography

Macro photography is another area in which infrared photography stands and falls by contrast, but here there is a great difference from landscape photography. Even objects made from different materials and having completely different colors may reflect infrared light in the same way, which means that they will appear in pictures as the same shade of gray. For example, a bright yellow dandelion against a green summer meadow will look white, just like the surrounding grass—the color contrast is lost completely. But if shot against the blue (in infrared: black) sky, the flower will stand out like a sculpture. An infrared-modified compact camera with a live-image screen is the ideal tool to gauge these contrasts. Such a camera is also ideal for evaluating the depth of field, which a macro lens would make very narrow. Most compact cameras do not offer great capabilities for producing good macro shots. Then again, special macro lenses can be used on some of these cameras. Stock cameras (especially SLRs) are severely limited in this field. There is the advantage that the aperture can be reduced, but this comes at the price of even slower shutter speeds. When shooting in nature, this will usually result in motion blurring even when the subject seems to be completely still. Shooting in the studio is a much better way to go. A studio setting allows for better control

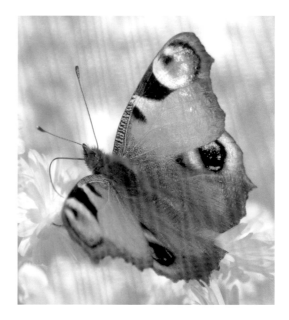

▲ *The butterfly in this shot contrasts with the flowers (here appearing in white). Modified Nikon Coolpix 5400, +4 macro lens.*

over composition and backgrounds, and we can take all the time we need for meticulous focus adjustments. With difficult subjects, it will be especially necessary to take a series of experimental shots in order to close in on the ideal focus point.

# Filters for Infrared Photography

Filters are generally an important aid in photography, and they also have certain applications in infrared photography.

- UV and skylight filters are of no use in IR photography.

- As in visible light, polarizing filters cut out or reduce reflections on glistening, nonmetallic surfaces such as water or glass. A polarizer will also render the already dark infrared sky even darker.

- Star effect and other specialty filters can usually be employed without problem.

- Soft lenses will produce their expected effect, but depending on the lens, the effect may be unevenly distributed.

- Corrective lenses and color filters have no effect, because the infrared filter removes most visible light.

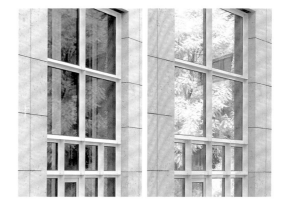

▲ *Left: without polarizer. Right: with polarizer. Even in infrared light, polarizers will be effective in reducing reflections.*

▲ *Effect filters, such as this 6-point star filter, can be used in infrared photography in the usual way. However, they should not be overused.*

# Using the Flash

### The Dark Flash Technique

Sometimes it is better not to be seen. This is not only true in criminal investigations where persons need to be put under surveillance, but it also holds true in nature photography. When photographing wildlife, the intense burst of light sent out by a flash generally reveals the photographer's location and usually rules out the chance for a second shot. In addition, some shy, nocturnal animals can be tremendously disturbed by a flash. There is a way around this if we use a camera that has been optimized for infrared in combination with a flash equipped with an infrared filter, or with an infrared trigger as a flash. The light sent out by such a trigger is invisible to humans and many animals. Just a small red spot is visible to us, and this only if we look directly into the unit. But because of the high IR sensitivity of modified cameras, the unit's IR beam is strong enough for shooting pictures—in black and white only, of course. However, before we use this technique to stealthily photograph animals in the dark, we need to first learn whether the subject's eyes are sensitive to the wavelengths emitted by our IR flash.

### Conventional Flash Units

Modified cameras from which the internal IR filter has been removed can be used with any normal flash unit. Of course, if a studio flash system is used, all lamps must be triggered by a cable release or by radio signal; otherwise, the light of an IR trigger would be visible on all pictures. Regular flash units will not work unless a camera has been modified for IR photography.

*An infrared trigger can be used as an IR flash, in combination with an IR optimized camera.*

▲ *While black plastic reflects very little infrared light, human skin tones appear very bright.*

*Modified Nikon Coolpix 5400, 28 mm, aperture 5.2, 1/400 sec., ISO 50. Flash with softbox. Photo: Tabea Harnischmacher.*

▲ *Chestnuts. The black slate remains black, but both the green chestnut hulls and the brown chestnuts inside show up as almost white.*

*Infrared modified Nikon Coolpix 5400, 80 mm, aperture 4, 1/30 sec., ISO 50. Two flash units with soft boxes.*

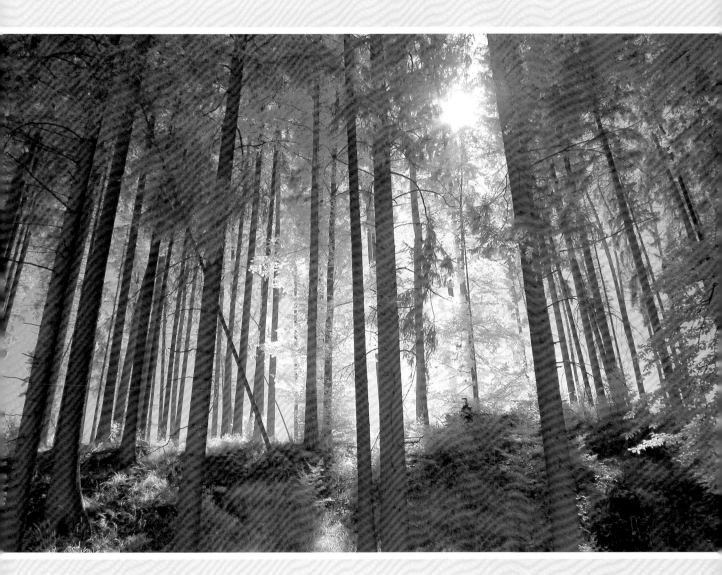

▲ *Forest against the sun. Infrared*
*modified Nikon Coolpix 5400, 28 mm,*
*aperture 4, 1/400 sec., ISO 50.*

# The Digital Darkroom

# Black and White Conversion

Only in rare cases do infrared photographs not require post-processing. Basic knowledge of digital image processing is a prerequisite here; therefore, we should become familiar with Adobe Photoshop or similar processing software. The following techniques are based on Photoshop versions CS2 and CS3. Some of the steps described may be somewhat different in older versions or with other software, but the basic principles remain the same.

If we want just black and white output, we first need to convert the camera's color picture into grayscale, but simply deleting the color information during a regular conversion to grayscale does not always work so well. If the original picture was taken with automatic white balance, the red channel will be quite saturated, which makes a conversion into levels of gray rather difficult. One method is to deal separately with each color channel of an RGB image, which opens the path for a much better conversion. Each channel can be copied into an interim file, which can then be used as a grayscale image for further processing. The channel palette can also be divided into several channels. However, we have to be careful with the blue channel. The image quality in the blue channel (particularly in JPEG files) is decidedly lower than in the other two channels. Better results come with a conversion through the channel

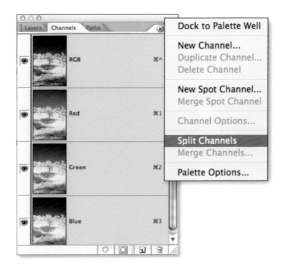

▲ *The command Multichannel splits the color channels. Each can be used as a grayscale image.*

mixer or through the Lab Color mode. We will take a closer look at both possibilities in the following sections. Of course, if the camera offers a black and white mode we can choose to use it, but we should be aware that a later conversion of RGB images offers much greater flexibility.

# Black and White Conversion in Lab Color Space

The Lab Color space (officially named CIE 1976 (L*, a*, b*)) offers a convenient method for the conversion of 8-bit or 16-bit RGB pictures into grayscale images. Lab mode has greater color fidelity than RGB and CMYK, and makes the conversion almost free of quality loss. Therefore, it is a good option in order to achieve a maximum range of colors or grays in an image. If the camera does not allow a separate white balance or the filing of images in the RAW format, Lab mode would be another good option to achieve an image rich in details but low in noise. The L-channel is particularly important: "L" stands for lightness. This channel contains the entire brightness information independent from the image colors.

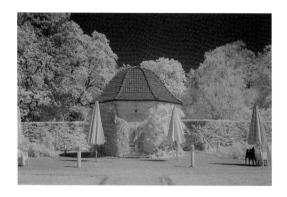

▲ *The original image, shot through a Heliopan RG715 filter and with automatic white balance. A simple conversion to grayscale would lead to unsatisfactory results.*

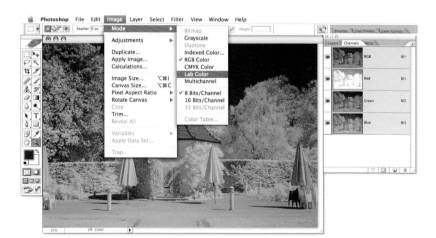

◄ *We first convert the image from RGB to Lab by choosing Image ⋯⟩ Mode ⋯⟩ Lab Color. The conversion to the Lab space works with 8-bit as well as 16-bit pictures, and is also a good option for the subsequent processing of pictures coming from a RAW converter.*

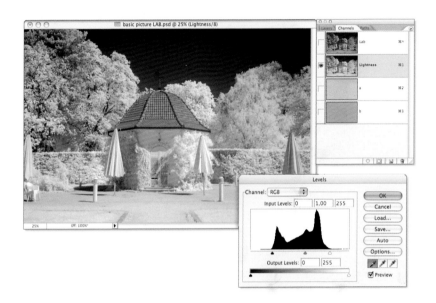

◀ Now we change from the view Layers to Channels, and then select the channel Lightness. At this point we can manually adjust the values either by using the eyedropper tool to select the black and white reference points, or by moving the sliders for light, medium, and dark until the image appears as we desire.

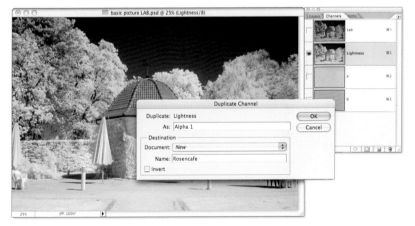

◀ We can duplicate the channel by choosing File ⋯▷ Save As... and then giving the new file a chosen name. In case the software does not have this option, we could just duplicate the Lab Lightness, save it, and then import it into a new file.

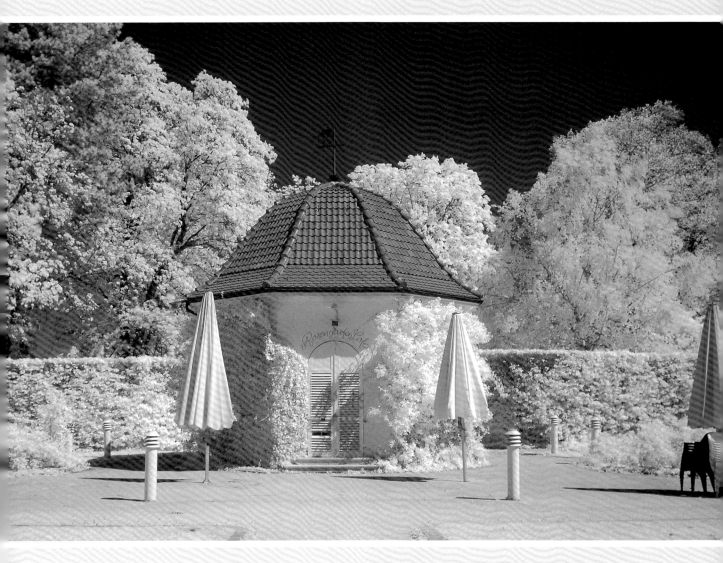

▲ The processed picture shows distinct shades of gray, which would have been lost had the picture been converted to grayscale with a simple "Discard Color Information" command.

# Grayscale Conversion with the Channel Mixer

Photoshop's Channel Mixer function is an excellent tool for executing conversions from color to black and white. From the drop-down menu, select Image ···} Adjustments ···} Channel Mixer. Checking the Monochrome box will change the Output Channel to Gray. Now we can use the sliders to individually select the degree to which each channel will be used in a monochrome image. It is possible to use the Channel Mixer directly on the original image, but it can also be applied to a new layer, which has two advantages. First, it makes it possible to adjust changes after they have been made. Second, each layer also has its own mask. By using a brush or air-

brush tool on an activated black foreground color within this layer mask, the unprocessed image underneath can be partially blended in or out. Just to top things off, we can now add one or more additional layers. For example, we could add layers in order to tint the picture via the Hue/Saturation function, or we could use the Gradient Editor to manipulate the color value distribution across the image. In addition, each layer's effect can be invidually changed by adjusting the layer mode and opacity.

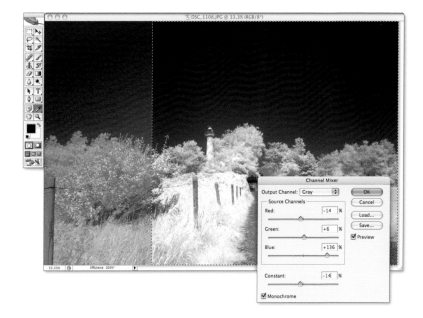

◀ *After checking the option box for Monochrome, the intensity of each color channel's role in the conversion to black and white can be adjusted by moving the sliders. The left side shows the original, unmodified image.*

# Color Levels and Gradient Curves

The traditional method for the correction of contrast and color levels is done with the Curves and Levels functions. While the Levels environment is perfectly suitable to quickly adjust lights, medium gray, black, and the relevant output levels of an image, the Curves environment offers many finer adjustment functions. However, this requires more experience and practice. Very subtle changes can be achieved by selecting and moving the black point (lower left) and white point (upper right). This allows lights, darks, and midtones to be carefully adjusted. To do this, we first click on the curve to define a point to be

changed. Now by clicking and dragging that specific point, we can brighten this specific tonal range by lifting the curve, or we can darken it by lowering the curve. The range can also be adjusted by moving the black and white points. Ideally, we will have created a layer for these adjustments so that we can always go back to the original image or take additional steps by changing the opacity of the layer.

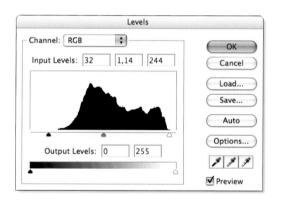

▲ *In the Levels environment, we can change darks, midtones, and lights in the image by moving the sliders. Another method is to use the eyedropper tool do define white and black points as well as medium gray.*

▲ *This is an S-shaped gradient curve. Lifting the first quarter and lowering the last quarter of this curve results in a more contrasty image.*

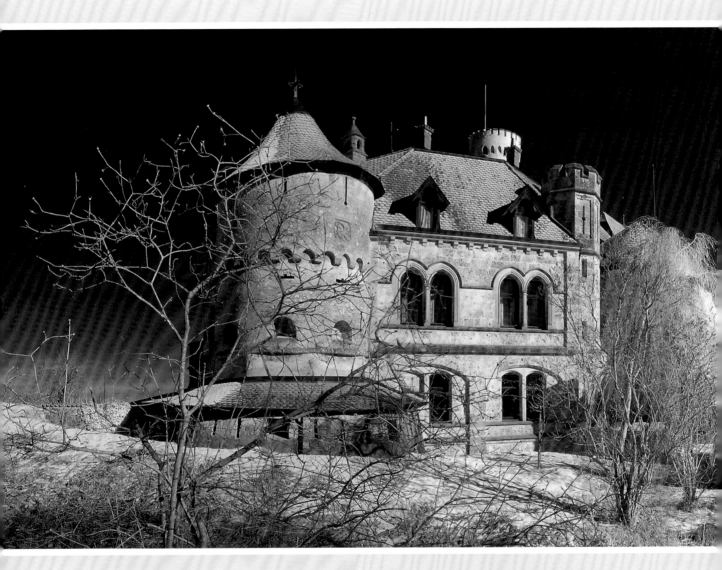

▲ Lichtenstein Castle. The changes to the sky are clearly visible. The sun behind the photographer's back turns blue sky to almost black. The more the camera is directed toward the sun, the greater the risk of lens flare; however, this also can be used as a creative effect.

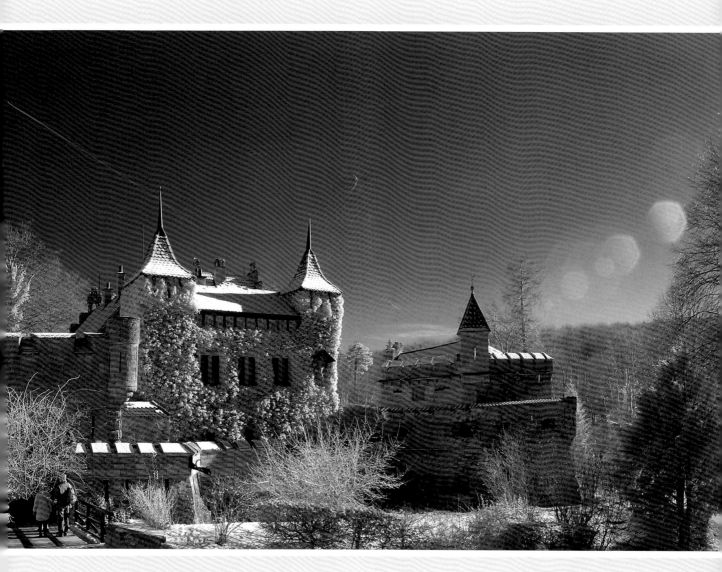

*Infrared modified Nikon Coolpix 5400, 28 mm, aperture 4, 1/250 sec., ISO 50.*

# Optimizing Pictures with Layers

◄ We first duplicate the background layer and set the mode to "Soft Light". This causes the image to have more contrast. To avoid losing track of all the layers and their modes, it is best to name each layer descriptively. In the second step we duplicate the background layer a second time and put it on top of the stack. We select "screen" from the layer menu.

◄ The "screen" mode also brightens the picture. Now we can adjust the picture's brightness and contrast by altering the opacity of each layer individually. This does not change the image on the background layer. Fading out the top layers still preserves the original image in the background. Now we can save the image as a Photoshop file so we can make more adjustments at a later time.

# Pictures with Great Tonal Range

Photographic technology is rather limited when it comes to reproducing strong contrasts. The human eye is able to perceive a huge range of contrasts—much greater than even the best photographs. Attempts to push the range of photographic contrasts too much result in overflowing light or general darkening. One workaround is to create several differently exposed shots of the same subject, which can then be combined into one image. But in infrared photography this method could easily cause another problem: Due to the long shutter speed, the subject will often have moved while the successive shots are taken. Combining the resulting shots would lead to rather unattractive images. Therefore, it is better to simulate differently exposed shots from a single data file. The advantage of the manual method we illustrate here is that the corrections can be done very subtly and with great precision. By adding additional layers (some of which have reduced opacity) and by painting with a brush or airbrush tool on the layer mask, we can further fine-tune and improve the result. Those of us who often manipulate images in this way would be well advised to consider acquiring High Dynamic Range (HDR) software. These widely available applications can automate many of the necessary steps.

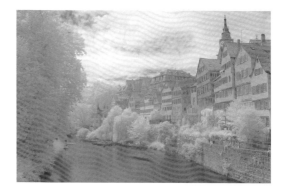

▲ *The unprocessed original image is very poor in contrast—a result of the soft light from the overcast sky.*

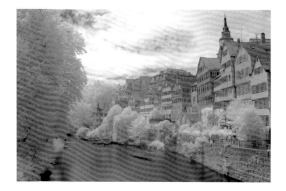

▲ *An automatic tonal range correction yields more contrast, but it also turns the overall picture rather dark and gloomy. On the other hand, brightening the image to accentuate the plants would cause the light parts of the sky to lose texture and burn out.*

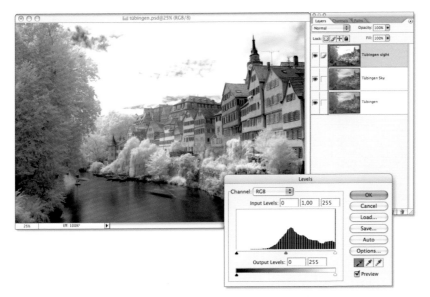

◀ First we duplicate the background layer twice. Each layer should be descriptively named. Next, we adjust the top layer's tonal range to the point where the bright plant parts still show barely defined structures. At this point, the light clouds will burn out and disappear.

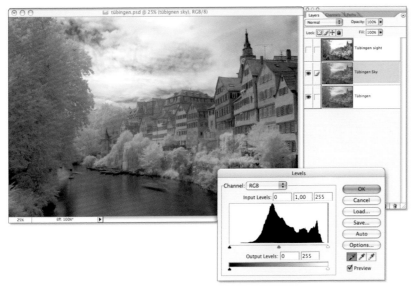

◀ Next, we fade the top layer out and darken the layer underneath until the sky's tonal range reaches our expectations.

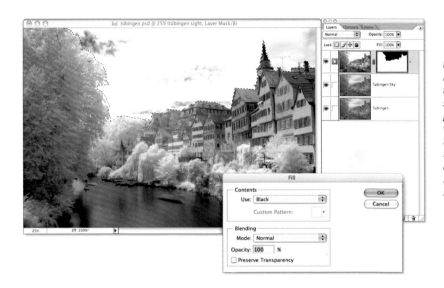

◀ Now we create a mask for the top layer by choosing Layer ···▷ Layer Mask ···▷ Reveal All. Next, we turn to the subject and select the sky with the lasso tool. Then, we fill the selection in the layer mask with black. This makes the sky in the layer underneath visible. At this point it would be best to apply a soft edge effect on the layer mask in order to conceal the transition area.

◀ Now we save a copy of the file, without layers, and give the file a new name.

◀ In the next step, we open the copy and duplicate the layer by choosing Layer ⋯▶ Duplicate Layer. However, this time we target the original file. This causes the duplicate layer to appear above the active layer of the original file.

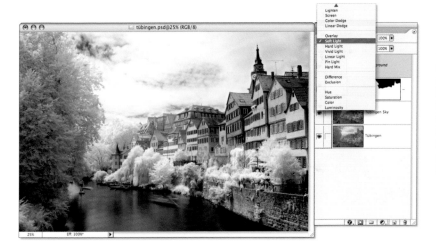

◀ Next, we apply the "Soft Light" command from the layer mode palette to the new layer. This brings further enhancement to the contrast. The effect can be regulated smoothly via the top layer's opacity setting. Finally, we save the entire file inclusive of all layers. This allows us to return to the file at a later time for further corrections.

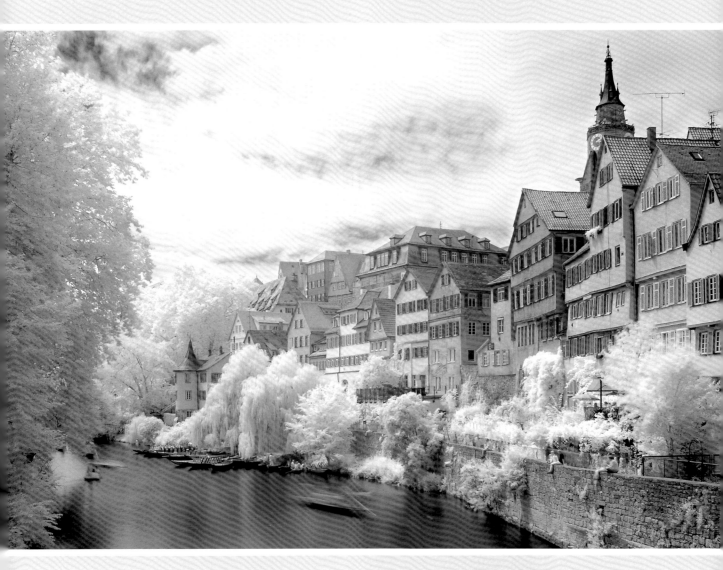

▲ *A view of the college town of Tuebingen. This processed picture now has enough definition in all areas, and* the Wood Effect is more readily visible. Nikon D70S, 24 mm, aperture 6.3, 5 sec., ISO 200, Heliopan RG850.

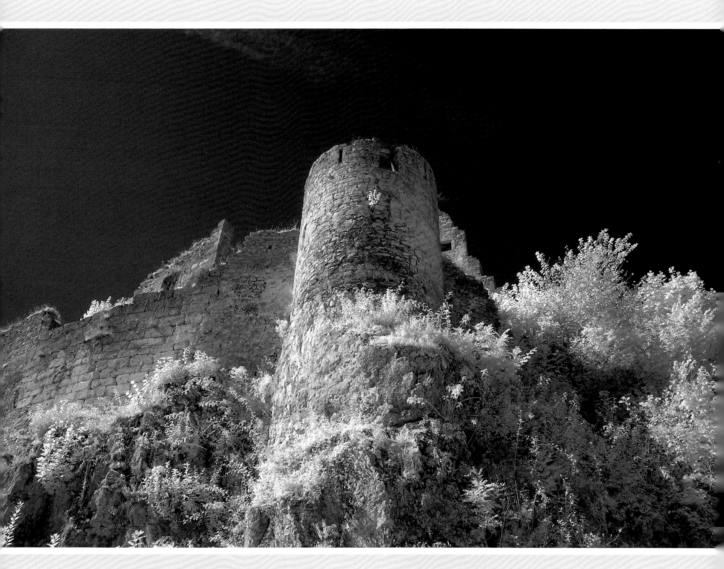

▲ Castle ruins of Hohenurach. The mild
sepia tone gives this shot a nostalgic feel.

Infrared modified Nikon Coolpix 5400,
28 mm, aperture 4.4, 1/300 sec., ISO 50.

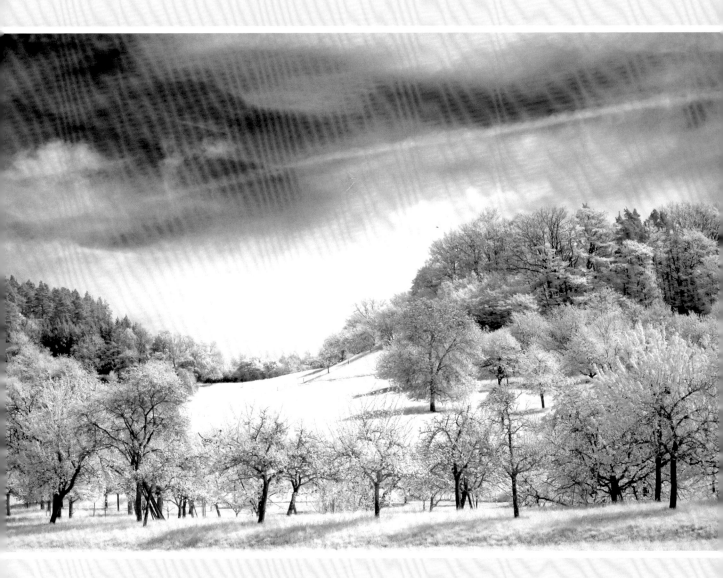

▲ *Orchard and meadow near Tuebingen.*
*Nikon D70S, 50 mm, aperture 8, 5 sec.,*
*ISO 200, Heliopan RG780.*

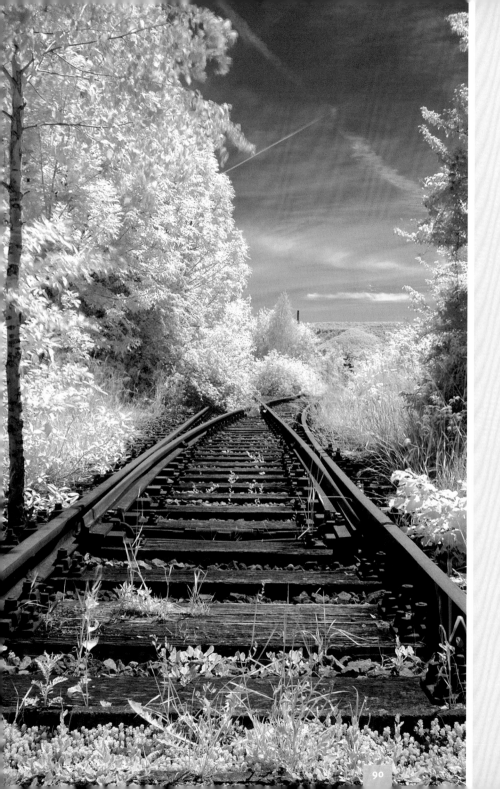

◀ Railroad tracks. The low camera angle adds a dynamic quality to the shot. The abandoned railroad tracks draw the viewer into the far depths of the picture. Nikon D70S, aperture 13, 1.6 sec., ISO 200, 24 mm, ISO 200, Heliopan RG715.

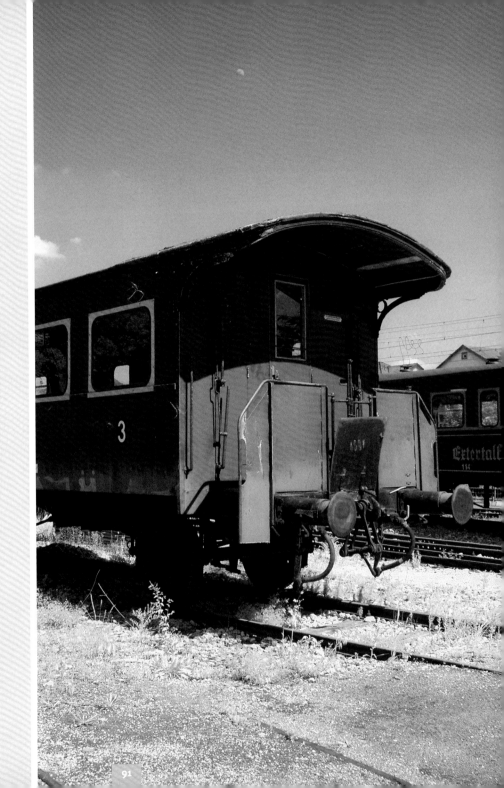

▶ *Historic railroad carriages. Because the RG665 filter used for this pictures allows a relatively large amount of daylight to pass through, it is possible to make handheld shots—provided there is good light and a high ISO setting is selected. Nikon D70S, 24 mm, aperture 4, 1/20 sec., ISO 1600, Heliopan RG665.*

# Color Infrared Photography

In truth, the often-used term "color infrared photography" is misleading. Infrared light does not carry true color information, but only reveals shades of gray depending on the intensity of the reflected light. The color effect of some shots is only the result of the additional visible light, which has passed through the filter. Depending on the kind of filter used, more or less visible light can reach the sensor and influence the image. In essence "color infrared images" are the result of a mixed light environment. If a filter blocks the entire visible light spectrum, the resulting image will be black and white only (provided that a manual white balance has been performed). The more visible light is allowed to pass to the sensor, the more the image will be infused with colors. The colors can later be enhanced, modified, and altered on the computer screen. In case we are working with a restrictive infrared filter that only produces black and white images, it is still possible to add color effects by removing the filter from the lens during the exposure, making the entire spectrum available for the duration of the exposure. Double exposures are another means of achieving this. Here, one exposure is made with filter, and another without it. This can produce very interesting color effects. Because the results are dependent on the type of filter, the shutter speed, and the white balance,

▲ *Left: Original, unprocessed image, filter RG 665. Middle: Automatic levels correction in RGB mode. Right: Automatic levels correction in Lab mode applied only to the lightness (luminescence) channel.*

there is a lot of room (and need) for experimentation. A correction of tonal curves is almost always necessary. But if this is done in the RGB mode, all channels may be included in such a way that unwanted color aberrations could result. The workaround is the same as mentioned earlier: we first convert the RGB image into Lab colors, and then we select the Lightness channel. Since this channel only contains the brightness information, a tonal range correction influences neither hue nor saturation.

# Partial Colorization with the Channel Mixer

Photoshop's Channel Mixer offers an effective and convenient method for colorization, and similar functions are available in other image processing software. Only a few steps are necessary to swap and mix color channels simply by moving sliders, and to change the picture into grayscale. If the Hue/Saturation function is employed, it is even possible to target specific parts of the picture for refinement and adjustments. The raw material is a color infrared picture made with filters such as the RG780, RG715, or RG665. Depending on the type of filter used, the proportion of visible light varies, and

therefore, the image colors are more or less intense. Processing makes it possible to change the commonly red-tinted sky (resulting from a mix of visible and infrared light) into a more realistic-looking blue. Extreme color shifts as well as small and subtle adjustments are possible. Because of the great variety of possibilities and combinations, spending an hour in front of the computer screen just to play out different variations of one image seems like a worthwhile pursuit.

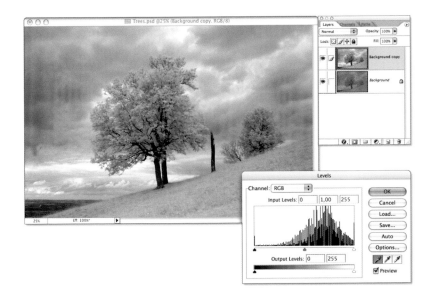

◀ *It is best to work on a copy of the original file, or on a duplicate layer as shown here. This allows us to go back to the original at any time. First, we should use the eyedropper tool to define the black and white points, taking care that the lights and darks of the picture still show detail and texture.*

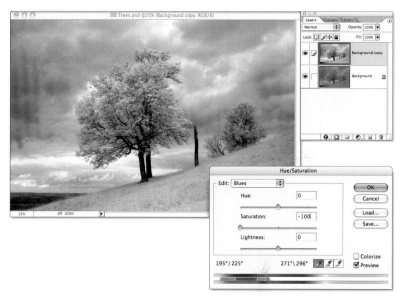

◀ *We can now reduce the blue saturation via the Hue/Saturation function to the point where the blues are only recognizable as grays. We can pick the targeted color range using the slider at the bottom of the window.*

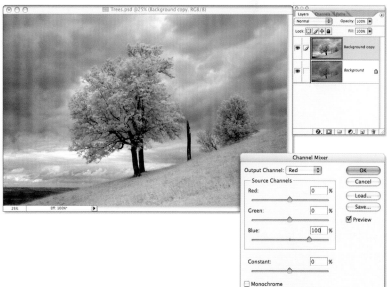

◀ *Next we select the Channel Mixer by choosing Image ⋯▷ Adjustments ⋯▷ Channel Mixer. This allows us to mix the channels by moving their sliders. Here is the procedure for changing the original's reddish sky to a more realistic blue: first we select "red" as the output channel. We then change the red value to 0%, the green value to 0%, and blue to 100%. This will produce a green sky. Now we change the output channel to blue and change the values of red to 100%, the value of green to 0%, and the value of blue to 0%.*

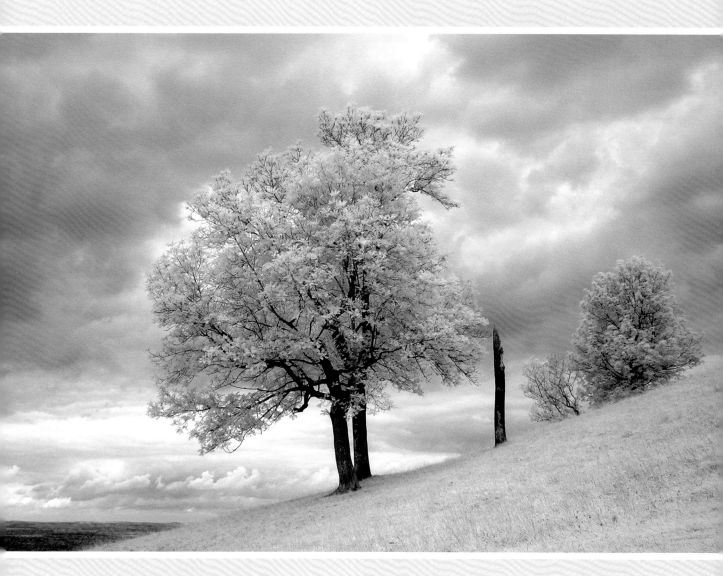

▲ *After the channel swap in the Channel Mixer environment, the processed picture appears in black and white, but with a partially blue tinted sky.*

# Using the Channel Mixer for Color Effects

The swap of individual channels from a normal image to channels from an infrared image can produce very interesting color effects. Of course, it is essential that both images show the exact same picture frame. This would be undermined by even the slightest movements of the camera, or by the minute changes of the subject—such as wind-induced motion or changing cloud structures. At any rate, a stable tripod is essential. We also need to take into account the focus difference between normal and infrared light, thus it would be best to use a lens with an infrared index or at least a short lens with apertures so low that the depth of field spreads out over the entire image. Ideally, landscape shots should be taken when there is no wind or clouds. Shots of buildings offer a little more leeway, but the color changes are less effective without the Wood Effect.

It is always a good idea to practice the entire procedure a few times before taking the actual shot. When it is time for the real "action", we should be able to perform all movements without shaking the camera at all. We should do the infrared part of the exposure first, because it is easier to remove the filter from the lens than to attach it without disturbing the camera. One trick is to screw the filter very loosely onto the lens, as it is certainly easier to remove a loosely connected filter. We will also need to experiment by taking a series of shots with various exposure settings. After that, we can remove the infrared filter and perform a white balance in accordance with the light conditions. At this point we might have to refocus. Another series of shots should be done in normal daylight as well. This makes it possible to later select the best shot on the computer.

Astonishing color effects can be achieved not only through channel changes in RGB, but also in other color environments. For example, if the lightness channel of an infrared image is swapped with the black channel of a regular image in the CMYK mode, vapor effects are drastically reduced. (Of course this will affect the colors somewhat). Working with the conversion of various images can be a great inspiration and can lead to interesting surprises.

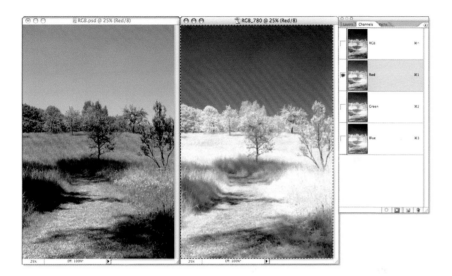

◀ Using the original image, we first open the Channel window and select the red channel. Now we copy the entire channel into an interim file.

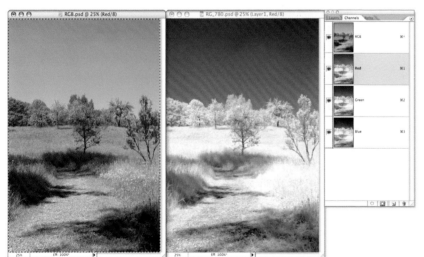

◀ After changing over to the working image, we copy the red channel of the original image and insert it into the red channel of the target image. A slight shifting of the subject is sometimes unavoidable, but this can often be counteracted by moving the channel slightly. To do this, we activate the eye symbol next to the RGB view window and use the arrows to move the channel by one pixel at a time.

# Channel Swap Variations

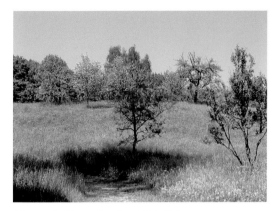

*Picture A: Shot taken in visible light.*

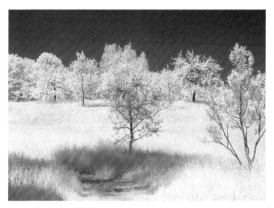

*Picture B: Infrared shot using a Heliopan RG780, automatic curve control.*

In the following six example images the (A) or (B) designations tell us from which of the above two pictures the respective channels were taken. These demonstrate all possible channel swapping combinations.

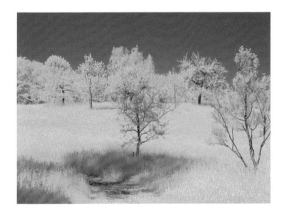

*Channel Combination:*
*Red (A), Green (B), Blue (A)*

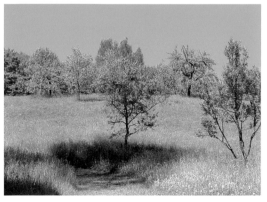

*Channel Combination:*
*Red (B), Green (A), Blue (B)*

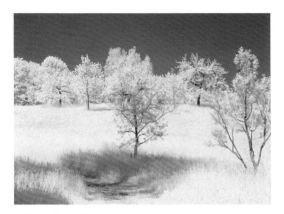

*Channel Combination:*
*Red (B), Green (B), Blue (A)*

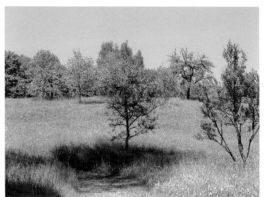

*Channel Combination:*
*Red (B), Green (A), Blue (A)*

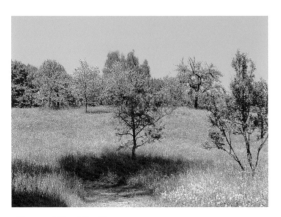

*Channel Combination:*
*Red (A), Green (A), Blue (B)*

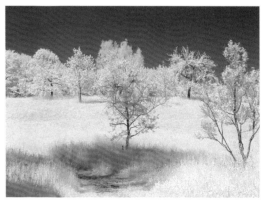

*Channel Combination:*
*Red (A), Green (B), Blue (B)*

# Colorization and Duotone Effects

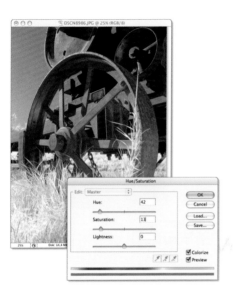

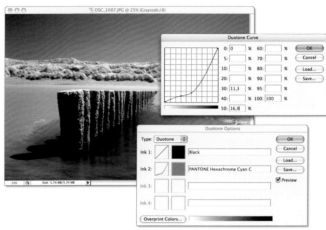

Photoshop offers several methods to manipulate colors in an image. The Hue/Saturation adjustment should be used whenever we want to change overall image colors in an even way. After checking the Colorize box, we can move the Hue and Saturation sliders until we get the look we seek. In addition, we can use the Lightness slider to change the overall brightness of the image.

Another method is the Duotone Mode. This function allows for much more subtle adjustments. First, the image must be converted into a grayscale file. Next,

we can choose Image ····⟩ Mode ····⟩ Duotone from the drop down menu, which brings up a window from which another "ink" can be selected. (Note: You first have to turn the image into a background layer. The command does not work for all layers.) Clicking on the gradient curves symbol opens another window. Here, we can adjust the color intensity individually. Interesting effects can be achieved by adding more colors, or by replacing black with another color. At the end, we can convert the image back into the RGB mode.

Dealing with shooting techniques in previous chapters, I have mentioned the softening effect of the analog infrared film from Kodak, specifically the HIE 2481. There is a way to approximate this effect in Photoshop. First, we should duplicate the base layer and give it a distinctive name. Next, we select the layer from the Layers palette and choose "Screen" in the small drop down at the top of the layers tab and then set the opacity of that layer to 50%. This will markedly brighten the light and medium sections of the picture. Then from the drop down menu, select Filter ⇢ Blur ⇢ Gaussian Blur to add the filter effect to the top layer, which will bring up another window. From there, the effect can be adjusted by changing the radius of the filter. Because we already created an inverted layer with the above steps before applying the filter, we can monitor the effect on the screen and fine-tune it by alternating the radius. Another way to alter the filter's effect is to adjust the opacity of the top layer. Interesting variations can be achieved by changing the layer mode of the softened layer, or by adding more duplicated layers—each in a different mode. After achieving the result we want, we can combine all layers into the background layer and give the file a new name.

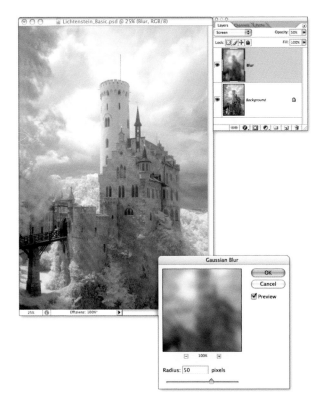

▲ The effect of the softening (blur) filter can be regulated through the intensity of the Gaussian blur or though the opacity of the layer on which it is used.

▲ Guitar. The colorization is the result of
a conversion in the Duplex mode.
Infrared modified Nikon Coolpix 5400,

42 mm, aperture 5.2, 1/1000 sec., ISO 50.
Flash system with softbox.

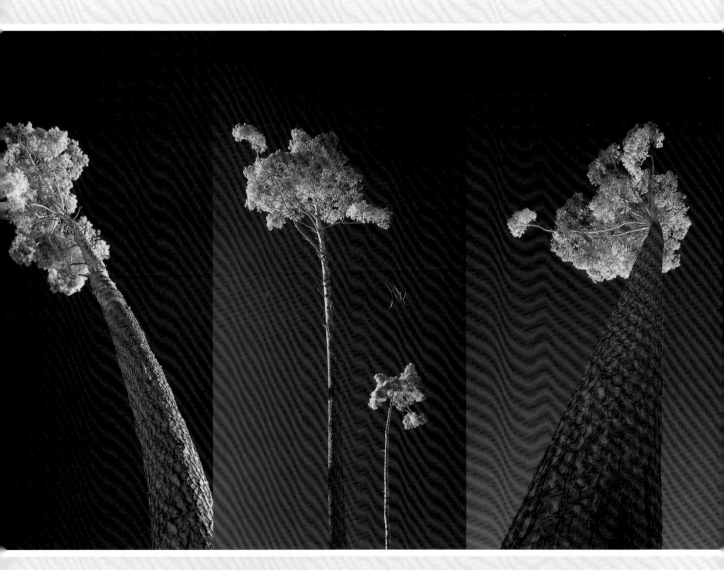

▲ *Trees in Schoenbuch near Tuebingen.
The low angle of the winter sun produces
a wonderful, grazing light.*

*Infrared modified Nikon Coolpix 5400.*

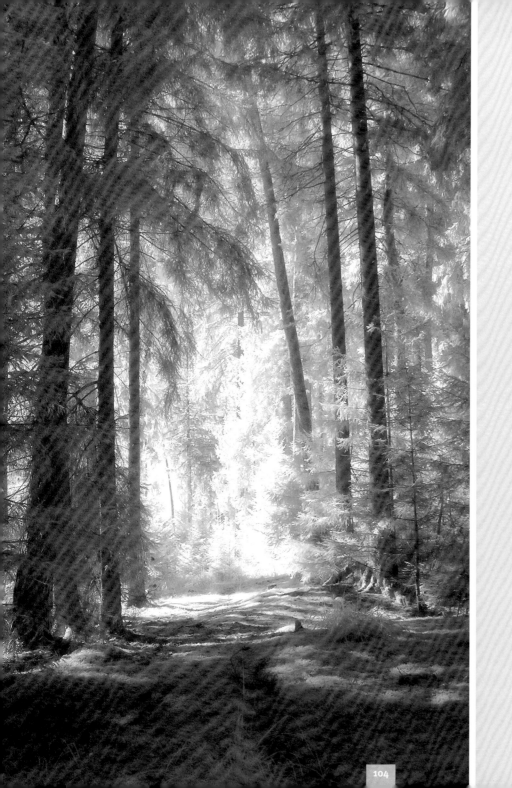

◄ *Forest near Tuebingen. Infrared modified Nikon Coolpix 5400, 28 mm, aperture 5.6, 1/125 sec., ISO 50.*

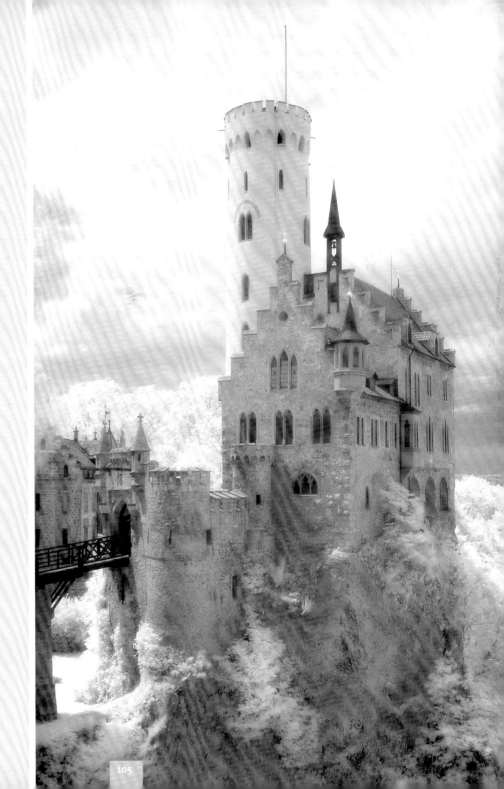

▶ Lichtenstein Castle. Because a softening effect has been applied to a layer, the image reminds of a fairy tale. Nikon D70S, 24 mm, aperture 8, 6 sec., ISO 200, Heliopan RG850.

# Resources for Camera Modifications and Infrared Filters

Modifications of digital SLR and digital compact cameras
Filter glass for home built modifications
Tutorials for modifications
www.lifepixel.com

Modifications of digital SLR cameras
Infrared filters and neutralizers
www.optik-makario.de

Infrared filters
www.heliopan.de/Heliopan-Filters.pdf

Infrared filters of other manufacturers can be found in photography stores

Clip filter system
www.astronomik.com

Responsibility for the content of each web site rests with the web site operator.

# Other Books by Cyrill Harnischmacher

**Closeup Shooting**
A Guide to Closeup, Tabletop, and Macro
Photography

Closeup photography is one of the most fascinating areas in photography. This illustrated guide takes the reader on a journey into the wonderful world of small, smaller, and smallest objects and shows how to capture their beauty with photographic images. Each step is carefully explained; choosing the right equipment, using ambient or artificial lighting, and conceptualizing and framing the perfect shot.

Cyrill Harnischmacher explains all aspects of close-up shooting for inside the studio, as well as outdoors. This book is filled with beautifully illustrated examples and detailed instructions on how to set up a system and workflow for successful closeup photography.

April 2007; 132 pages
978-1-933952-09-3
US $24.95, CAN $32.95

**Low Budget Shooting**
Do It Yourself Solutions to Professional
Photo Gear

The serious amateur photographer often faces the problem that after buying cameras, lenses, computer gear, and software, the spending never seems to end. More gear is needed for studio, tabletop and flash photography, and for accessories here and there. That's where this book comes in. *Low Budget Shooting* is the one-stop source where you will find instructions and a shopping list on how to build an array of useful and inexpensive photographic tools.

Filled with full color images and easy-to-follow text, this book shows how to build essential lighting and studio equipment. This clever little book is a creative and valuable resource for most any photographer.

June 2007; 72 pages
978-1-933952-10-9
US $19.95, CAN $25.95